ADVA
AN (

"Writte... ...nt memoir offers heartfelt revelations about the importance of family, the innocence of childhood, and the nature of love and grief. His is the hard-knock story of a rise from prairie farm boy beginnings to the directorship of Canada's most prestigious grassroots theatre. Coleman is a wise and masterful storyteller."

—**DWAYNE BRENNA**, award-winning author of *New Albion* and *Nights That Shook the Stage*

"A frequently outrageous yet ultimately poignant romp through the life of Layne Coleman: artist, addict, widower, father, and irrepressible seeker of joy, even amidst despair. Reading this was a restorative act."

—**JENNIFER DELESKIE**, writer

"Simple, fresh, deep, and true. A love story for the ages. Beautiful, beautiful writing. A heart and soul worth visiting."

—**JIM GARRARD**, playwright, director, actor, former head of Toronto Arts Council, founder of Theatre Passe Muraille

"Layne Coleman's *An Open-Ended Run* is a beautifully written memoir that captures the raw essence of life, love, and loss. A gift to the world of Canadian theatre, this book offers profound insights into the artistic journey, the

power of resilience, and the beauty of human connection. Coleman's story is a love letter to humanity, illustrating the true meaning of being alive and open to love—savouring its joys, swallowing its pain, and continually learning and relearning to live through it all. A truly captivating and unforgettable read from start to finish."

—**NINA LEE AQUINO**, Artistic Director,
English Theatre, National Arts Centre

"As each successive story unfolds in this rich, rewarding memoir, what emerges is a portrait of the soul of a prairie boy adventurously, recklessly, and sometimes dangerously immersing himself in the alternative Toronto theatre scene while searching for his holy grail—only to have her die in his arms prematurely. Told with bold, graceful, sometimes mournful elegance, charming laugh-out-loud wit, and an elderly man's hard-earned wisdom, Layne Coleman's wonderful stories about complex characters in fascinating relationships holds you in its spell until its remarkable life-affirming conclusions. *An Open-Ended Run* is an emotional celebration that punches, wails, betrays, caresses, loves, thrills and, most of all, rewards, with its clear-eyed lack of self-pity and a never-give-up sensibility. You'll want to want to read it twice."

—**BILL HOMINUKE**, co-writer/director/producer,
The Shape of Rex

"I've never read a memoir by a man who admits to so much. Layne Coleman writes about art, love, and loss with both

knee-buckling passion and self-satirizing wit. He makes fatherhood, grief, and memory visceral. He conjures the fear, glory, and intoxication of being a performer—a prairie farm boy who ends up playing Hamlet. And above all, this is an unforgettable love story, set in a time of freedom-seeking. The full human range is here, in an unfolding of light and dark moments that is a sheer joy to read."

—**MARNI JACKSON**, author of *Don't I Know You?*

"Deeply personal, the grief and ecstasy are equally palpable."
—**MARJORIE CHAN**, Artistic Director, Theatre Passe Muraille

"Vulnerable and raw, Layne Coleman is the reluctant hero of his own story. His is a captivating journey to become a major voice in Canadian theatre while navigating breathtaking loss. His prose makes you feel as though he's sharing his story with you in real time and for the first time. Layne's story… offers a rare glimpse into the nascent days of homegrown Canadian theatre, a time when the cultural landscape was dominated by British and American influences. It's an essential read for those interested in the performing arts and the cultural landscape of Canada."

—**JENNIFER BREWIN**, Artistic Director, Globe Theatre

AN OPEN-ENDED RUN

A MEMOIR

LAYNE COLEMAN

University of Regina Press

Copyright © 2024 Layne Coleman

All rights reserved. No part of this work covered by the copyrights hereon may be reproduced or used in any form or by any means—graphic, electronic, or mechanical—without the prior written permission of the publisher. Any request for photocopying, recording, taping, or placement in information storage and retrieval systems of any sort shall be directed in writing to Access Copyright.

Printed and bound in Canada. The text of this book is printed on 100% post-consumer recycled paper with earth-friendly vegetable-based inks.

Cover art: "Closed Red Velvet Curtains on a Theater Stage" (modified)
 By altitudevisual / AdobeStock
Cover design: Duncan Noel Campbell, University of Regina Press
Interior layout design: John van der Woude, JVDW Designs
Copyeditor: Crissy Calhoun

Library and Archives Canada Cataloguing in Publication

Title: An open-ended run : a memoir / Layne Coleman.
Names: Coleman, Layne, author.
Series: Regina collection.
Description: Series statement: The Regina collection
Identifiers: Canadiana (print) 20240363345 | Canadiana (ebook) 20240363388 | ISBN 9781779400277 (hardcover) | ISBN 9781779400260 (softcover) | ISBN 9781779400291 (EPUB) | ISBN 9781779400284 (PDF)
Subjects: LCSH: Coleman, Layne. | LCSH: Actors—Canada—Biography. | LCSH: Dramatists, Canadian—Biography. | LCSH: Theatrical producers and directors—Canada—Biography. | LCGFT: Autobiographies.
Classification: LCC PN2308.C62 A3 2024 | DDC 792.02/8092—dc23

10 9 8 7 6 5 4 3 2 1

University of Regina Press, University of Regina
Regina, Saskatchewan, Canada, S4S 0A2
TEL: (306) 585-4758 FAX: (306) 585-4699
WEB: www.uofrpress.ca

We acknowledge the support of the Canada Council for the Arts for our publishing program. We acknowledge the financial support of the Government of Canada. / Nous reconnaissons l'appui financier du gouvernement du Canada. This publication was made possible with support from Creative Saskatchewan's Book Publishing Production Grant Program.

For Charlotte

CONTENTS

Cheese Crackers 1
The Audition 9
Dallas Rules 21
An Actor Prepares 33
The Tsunami 69
The Undertow 97
Happy New Year 111
Eighteen 125
Eat Ambition 135
An Ancient Plague 143
Opening Night 153
Memories of Ice Cream 169
Five Days in February 181
Trust and Obey 197

Acknowledgements 207

ENDED
RUN

CHEESE CRACKERS

A man is saved if he remembers the beautiful things in his childhood. I went down to the basement for that reason. The food that was delivered to the house went there for a waiting period to let the virus, if there be any, dissipate, and after a three-day cooling-off period, it was brought up to the kitchen to be washed with soap and hot water. It was the way it was. Easy enough to accept, although sometimes I had a hard time remembering not to touch anything, and if I did, I had to immediately wash my hands while singing "Happy Birthday" two times.

I opened the box, and inside was the familiar wax paper envelope. When I tore it open, the smell hurled me back in time to my childhood on the farm, being a small boy in the kitchen. My sister used to lather the cheese crackers in honey, and I remember it was always hard to open the honey jar.

There was no television in the farmhouse, but there was a radio in a cabinet, a cabinet so large that it occupied its own wall. The radio had dials that made it look like some kind of Mars flying machine, or so I thought when I was a boy. To me, it looked like the future. The radio cabinet was made from the finest wood and polished to a glossy sheen; to a child, it was real high-class furniture that had pride of place beside the piano, which no one could play. It was where my mother and father had been "saved." They'd put their hands on the radio as Ernest Manning's voice led them to a new life—a miracle of salvation that happened right where the little boy ate his cracker, an event that would change his life forever, although I did not know it at the time.

Sixty-four years later, I had returned to the spot. There was only a hole in the ground where the house once stood, the barn had crumbled like a dried cookie, and the land was swept clean of my family's life. Wild grasses grew unchecked. Although forlorn, the place was more beautiful than I remembered, for a young boy does not appreciate beauty so much. An old man does, and that's because it's almost all that is available to him; he has beauty, and he has his memories.

I had always wanted to write about the boy who lived on that land; I'd romanticized my childhood. The process of aging does that. Aside from my lost wife, I knew my early childhood was my one great love in life, but there was also an actress who'd become like my daughter's second mother, and now my son-in-law, and a grandson who

came like fresh hope. I loved the new baby the way I'd loved the boy who lived on the prairie farm, the same as I loved my daughter, the little girl who changed everything.

On the farm as a child, I'd played among the few stunted trees, hung from the fence posts, and climbed the mailbox as if it was a tree—there were few vertical places on the prairie. And in the emptiness of the land, my imagination turned everything into something else. Bales of straw became fort walls, and the abandoned well became an exotic vase containing forty thieves. This was the location of my *Arabian Nights*. I defended a kingdom of the free riding my black-and-white pinto horse, Patsy, my bareback companion, through the hot summer days.

Winter was a different kind of dream. It was when you noticed the light more, the hues and colours reflecting off the snow, which was like a magic quilt, a canvas that covered the painful memories of poor crops and the following despair, the catastrophes that arrived year after year. The storms brought a danger from somewhere so cold, so far north that you couldn't comprehend their origin. The furnace, its oil surging, its sound rumbling, burned full throttle through the endless winter. This was a Canada that did not come with pride or patriotism, or much of anything, aside from the hope that things would not get any worse. There was no safer feeling than to eat a cheese cracker smothered in honey during a blizzard.

I didn't have honey in the house in Toronto, where I was hiding out with my family, waiting out the virus. We

were temporarily hunkered down in a stone mansion near the Gay Village, on Church Street, while my daughter and son-in-law's house was being renovated. The dry and salty cheese cracker would have to do on its own. The taste of it without honey still evoked pictures in my mind, as did the baby, barely a year old, who made us all feel as if we'd been rescued even though it was a time of plague.

The child's parents and I were the only people the boy was likely to know for a long time. He had red hair, like his grandfather's brother Terry had, red hair that had been enough for him to be singled out for special treatment, and not always the good kind. But there was only the good kind of treatment for this red-headed one, the beautiful boy who drew me back into the past of my own wild beginnings, when I had lived unsupervised with endless acres to roam, a toy Mickey Mantle bat slung over my shoulder, and a frozen swamp to skate on in winter.

The cheese cracker also recalled the smell of oil in my nostrils, and the memory of the arrival of the truck bearing the life-saving fuel. It was always an occasion but also a source of great anxiety, for the oil had to be paid for. It was an anxiety that children don't understand; that paying for things rules each and every moment one dwells upon this earth.

I had just turned seventy, and it seemed true to me that old age came with a return to childhood, as well as with a new form of joy that I shared with my grandson. The joy of each precious moment unfolding in wonder. The way a

glass window feels under the tongue. The wobbly legs as a boy learns to stand and walk. A door jamb, a carpet leading upstairs; the sense of triumph with each crawl under a table. All the secret worlds to discover in the place where adults live their mysterious lives. Even the bumps and scrapes, the face plants of learning. The swift-coming tears, instantly forgotten; always moving on to grab hold of some new mystery.

It was a strange time I was living through with my daughter, her husband, and my grandson, locked up while waiting for the winter of the virus to pass. New anxieties were added to the familiar ones, and there was worry in the air. Yet there was nothing like the human capacity for love of a baby, of a young child, to create the world anew.

I spent my days caring for the boy as his parents worked online from inside the house. My daughter was writing scripts that hopefully would become shows. My son-in-law wrote articles for the *Globe and Mail* about Toronto's theatre community's struggles for survival during these difficult times, instead of writing his usual reviews of plays, all of them cancelled. Despite the hardship, it was a cauldron of creative endeavour. The pre-toddler understood nothing about the cellphones or laptops being used, but a smile would cross his face when he determinedly reached to touch their glossy surfaces, akin to how I had caressed the radio in the farmhouse when I was young. These were my grandson's Mars flying machines.

The old Margaret Atwood theme of survival never changed. But this was a new form of survival. No canoes or

Tom Thomson jack pines to paint. Our household was still a dream factory but in an uncertain time. We were lucky in new ways and unlucky in old ways as well. After decades of relative equilibrium and advancement, the world had become wrapped in danger once more.

One morning, my son-in-law told me that the original meaning of *apocalypse* in Greek was not *disaster* or *misfortune* but *revelation*. Apparently, we had the good fortune to live in a time of *apokalypsis*, for there was a revelation of how important family and community are; how essential those who deliver things are; how vital food growers had become; and how important the medical workers are, who were cheered each night at 19:00 hours by the pot-banging, drumming, and clapping that would break out on the balconies and front porches of our street, a few blocks north of the ancient Maple Leaf Gardens, the site of a Beatles concert and Toronto's last Stanley Cup, the latter so long ago that to remember it made you one of those most at risk in the current day.

Maybe it was time to read the Book of Revelation, I briefly mused, knowing that was never going to happen. The revelation my son-in-law was talking about was not like the one in the ancient text; it did not end with four horsemen. This was surely a beginning; I felt it in my bones: that hope must be created anew. This called for a new order, a modern-day version of Gandhi's spinning wheel, which he'd used to demonstrate to the masses that they could be self-reliant, that they could produce cloth as

he did, that they could take control of its production away from the robber barons of the British textile industry. In the present, there were new paradigms of thinking being formed, which questioned the assumed rights of the present imperial class, the powerful who benefitted from unfettered capitalism.

There was an increasing awareness that it was shameful that those who risked their lives to deliver essentials were paid so little. An increasing awareness that those who cleaned the floors of hospitals and attended to the patients were heroes, as were truck drivers, grocery workers, and everyone else who did the thankless and underpaid hard labour that made the world function. To top it off, the stock market was crashing once more, and millions were out of work. I knew what that had meant in the past for my mother and father. The dark cloud of the Great Depression was the shadow under which I'd lived my life. Although I was born well after that time, my parents were forged in that furnace and they never recovered, and I knew of their sacrifices. In these times, a new generation was bearing the burden of a world that had stalled, and I felt a wave of both concern and appreciation for all those younger than me.

It was a good time to enjoy each cheese cracker as it came.

THE AUDITION

When I saw her on the street, she turned and smiled. She gave me a new life then. Her look said, Follow me, let's fall in love for the weekend. I knew my life was going to change, and it did. She invited me into her film, gave me a starring role.

I didn't know who I was then or what I would become, but I felt a sensation, as if there was a subterranean river running beneath me. I let her write the first couple of paragraphs of the story, and then I found my footing.

She wasn't thinking about tomorrow, or even about an hour into the future. She wanted what she wanted from the present, and I just forgot about all the stuff that held me back. I knew as long as I kept my eyes on that face I was going somewhere I wanted to go. I didn't have to ask directions—this was like winning. Her eyes were a spotlight, and it was shining on me. She set me upon a vast stage, and I never once thought about the exit wings. Being with her meant no longer being afraid of dying. It was 1971, and I'd arrived

in Winnipeg with only the clothes on my back, having hitchhiked from Whistler, BC, to begin a new life.

She asked me if I'd like to go for the meatloaf at the Hudson Bay cafeteria. It was an invitation I couldn't refuse. Once inside and up the four floors, when the toques and scarves came off, I saw that underneath her winter wear she was as sleek as a sports car. She had green eyes, and she almost never looked away from me. I felt like I was being invited to a place deep in the forest. I imagined we'd soon be dancing around a fire together. She was a university student studying theatre and working with an amateur theatre company producing a play by Harold Pinter, *The Birthday Party*. She was looking for someone to work backstage. She said if I volunteered, I would meet interesting girls. I must have had the look of a lost boy who needed to be found.

She asked if I was gay. I blushed. It'd never occurred to me but once. In a hockey game in my teens, I'd been slammed to the boards and dragged along them for a short time. I hated the experience of it, and as I skated away chasing the puck and the man who'd taken it from me, I'd inexplicably had a feeling that I might be gay. Given the discrimination in society, I'd carried that worry quietly for a few years. I didn't tell the blonde Nordic beauty about it. She set down her fork, thought for a second or two, and then reached across the table. She comforted me by saying it was okay if I was—her husband was gay, and he was an immensely talented classical guitarist. She made it seem as

if gay equalled talent. The stereotype, yes, but I wondered if there might be some advantage in letting her believe I was gay. She asked me if I'd like to explore who I was at her house. She said she was good at helping boys find out who they really were. She asked me if I liked my meatloaf. I said it was the best meatloaf I'd ever eaten.

She told me Harold Pinter was a British writer who wrote plays unlike any seen before. They were filled with menace and unspoken threats. Everything was super normal on top, but underneath it was war. The men in the plays pretended to be confident, but they were mostly all talk and no action. The women in the plays knew their place, but they hated the men for their advantages. The green-eyed sports car said she liked Pinter because he made silence more important than talking. Then she reached across the table again, touched my arm, and told me not to worry, there wasn't going to be a test later. Then she pressed her knee against mine under the table. I knew it was no mistake. She kept it there as I finished the rest of my meatloaf. I figured I'd work on my silence and that might impress her. I said nothing more until I'd cleaned my plate. As I scraped the dish, I remembered somebody telling me earlier in my life that you should always leave a little bit on the plate. It showed good manners. Well, it was too late for that.

She had only eaten half of her meal when she handed me a cigarette, which I accepted. She asked me to light hers. I struck a match, and she took hold of my hand and drew it

to her cigarette. Her touch excited me, and I could tell she enjoyed making me feel like I was not in charge of whatever came next. She turned and looked at the room, swept her cigarette out to the assembled, and said, "Everybody here is in a Harold Pinter play." She then leaned in and whispered, "Would you like me to find out whether you're gay or not?"

My heart doubled its pace, and I took a long suck on my cigarette to calm myself. I stuttered for the first time in my life. "I-I-I'm not gay."

She smiled and told me I was cute and that she liked me very much. She said she rather hoped I wasn't gay.

She played with the ashtray for a time as if she was trying to decide which way she wanted the future to bend. Then she looked up, and instinctively, I hoped things were not going to take a turn toward the weird.

"Would you like me to spank you?" she said, laughing as if the idea amused her.

"Why would you say such a thing?" I asked. I was shocked and sort of felt like my manhood had been purchased for a slice of mediocre meatloaf.

"Are you upset? Don't be," she admonished me. "You're a farm boy. They're always being spanked."

"How do you know I'm a farm boy?"

"You eat like one. It's like you're in a hurry to get back on the tractor." She laughed again—not at me but at some other thing. Her laughter tugged at my heart. I wanted her to spank me then, but at the same time the thought of it didn't feel right.

"I'll tell you a little secret, if you like," she whispered. "Just between you and me. Don't tell anybody. You promise?"

"Who would I tell? I don't know anybody in Winnipeg. This is the first conversation I've had in a month."

"An idea just popped into my head," she said with mock seriousness. "I saw the two of us—once summer comes—camping at the bend of a river, and we were rutting like animals. And we didn't have human conversations, but communicated with grunts and growls. I tan your bottom and you cry and cry, and I promise you that after I'm done with you, you'll know if you're gay or not."

I searched for the right response and wanted to play along, so I did. It was fun to be around a girl who was so outlandish.

"What would I do backstage for this Harold Pinter play?" I asked.

"You'd be my assistant. You'd do the stuff I ask you to do," she said matter-of-factly.

"Okay, I'll do it."

She leaned back in her chair and began playing with her hair. This went on for some time. When she finally spoke, she said, "That was an example of a Pinter pause. You see how eloquent it is."

I knew I was in over my head, but I was stimulated by the challenge and recognized the same feeling I'd had when playing with matches as a child. I wanted to impress her, or maybe even scare her a little.

"I'd rather act in your play than work backstage," I offered with pretend confidence.

"Have you ever acted before?" she said, a little bemused.

"No. But I think I'd be good at a Pinter pause."

"Show me."

I pushed back my chair. I sat arms stiff, holding onto the table. I then came around to her side and stared off to where the kitchen was. I turned around and looked directly down into her eyes. She was waiting for me to do something dramatic. I leaned in and kissed her, and she didn't stop me. She had the kind of mouth that gets a lot of attention, I thought. There was a lot of lip to kiss, and when I felt like I'd covered the real estate pretty well, I straightened up and didn't say anything. We stared at each other for some time, and I was determined not to speak.

Then she said, "That wasn't a true Pinter pause. That was more like a kiss."

I shrugged and toyed, "I'd like to Pinter some more."

"You know, I'm married." she said.

"You said that, but I'm not sure I believe you. Where's the ring?"

"Nobody wears a ring anymore. I sure don't." There was another Pinter pause. "Would you like to come back to my place and I'll prove it?"

"How would you prove it?"

"By screwing you like a married woman."

"And how would I know what that would be like?"

"You'd know."

"Can you explain it?"

"I can show you."

She stood up and started walking And I followed. I was twenty-one years old and I'd never looked more forward to anything in my life.

About halfway down the escalator, fear hit me. What if I couldn't go through with it? By the time we got to the revolving door, I was ready to run. I felt like a coward, but I also wanted to know how the story would end.

* * *

She lived in a small ground-floor apartment in a building that had a fair number of units and depressing hallways. When we got to her door, she let me walk in first. I wondered if the gay husband was going to be there, if I was being led into a trap. For a moment, I wondered if the woman was insane and going to stick a kitchen knife into my guts. But then I noticed the number of books around, and it calmed me a little. Nobody gets killed in a library, I thought, but I would need something to drink if I was going to stay. There was no chance of going further if I was sober.

The Nordic beauty walked into a small room that I thought must be the kitchen, and when she appeared again, she had a bottle of wine. There were no glasses. None that I could see. Anyway, I didn't care about glasses.

She went over to the stereo and flipped her way through a few albums and pulled one out that she held up for me to see, and with one motion, she slipped out the vinyl and dropped it onto the turntable. It was Leonard Cohen—the album with the woman breaking free of her chains,

surrounded by flames, and gazing toward heaven on the back cover. I wondered, had I just met my Suzanne? Or would she be my Marianne?

She motioned to me with her free hand. "Gimme your belt."

"What?"

"I'm going to spank you first, before I make sweet love to you."

"Why?"

"You know why."

I didn't know why, but I slipped the belt out of my jeans. There was one long, godawful Pinter pause. The she took a long slug from the wine bottle and passed it over. I took a good slug as well. Then she went around back of me and pulled down my pants. She laid the belt soft against my buttocks and then tossed it onto a mattress that lay on the floor in the corner. I started crying then, not because it hurt but because it felt good to cry. I felt like I was auditioning for Pinter.

The woman then came round in front of me and took the wine bottle and had another long pull. She set it on the floor and led me over to the mattress where my belt seemed to smile at me, like some sort of demonic invitation.

"Tell me about your father," she said out of the blue. She wanted to know how deep the hurt was, the kind of hurt only a father could inflict. She'd read me perfectly. It aroused me to think of her as psychic. Some kind of clairvoyant. I reached for her breast, and stroking it with one

hand, I motioned with the other as if I was summoning the past. The performance and the wine inspired me. I told this story, as if I was auditioning for her:

> The old man hardly noticed me or spoke to me. He was strong as an ox. He had a terrible temper. He once killed a horse with a two-by-four. The horse wouldn't do what he wanted, so he just clobbered it. Killed it in front of the whole family. Yet the old man was a fierce Christian and made us go to church each week.
>
> Every Sunday I'd ride in the front seat, between Mom and the old man. I was the youngest of seven kids, so I got the star treatment. One particular Sunday, I had to piss like a Shetland pony. We were late getting to the church, and I told the old man I had to go, and he just barked, "Sit down." When the break came before the sermon, I was ready to piss in the bushes, but there were more members of the congregation standing around outside than usual. And for some reason, the outhouse was locked. I swore using every name I could think of. I was little, but I learned how to swear from my older brother. I'd heard him swearing when he would shoot frozen horse turds like hockey pucks at the barn door. He did all the work on the farm, and cussing was the only pleasure he knew. He sure wasn't a Christian.
>
> From inside the church, the old man heard me. "Who's using that kind of language?" he yelled,

knowing it was me. So I never got my piss, and the preacher was a long-winded bastard. I had to ride all the way home with my bladder cramping me.

When we got to the house, I ran upstairs knowing I was going to die for the swearing episode. I hid in the old man's closet. A bad decision. I could hear him coming up, and he was as mad at me as he'd been at that horse. He came straight to the closet, dragged me out, and whipped me with his belt. It went on for a long time. It didn't have the desired effect of making me a better person, but it sure made me hate my father. The old man demanded to know where I'd learned to use that kind of language, and I sang like a canary.

Later that night, my brother held the biggest Libby's bean can you could buy, filled to the brim with piss, above my head. My brother threatened me with it and accidently spilled it, dumping about a half cup into my mouth. The old man heard the ruckus and came up and nearly broke my brother's arm.

I couldn't have been more proud of myself. She believed me, but she had to: the story was true. It was a defining moment in my childhood, my first great moment of shame. I had betrayed my older brother Terry, and he paid the price. He had already paid many prices, and though I was very young, I knew his suffering. I felt bad about it most of my life, even though my brother has forgiven me.

Under her sweater, I could feel her nipple was as hard as a ruby, and what happened next made me feel as if I'd gotten the part in the Pinter play. I would be right about that. I ended up playing the fanatical Irishman, McCann, and everybody said I was the best actor in the show. The one critic who saw the performance wrote, "This first-time actor's pauses were uncanny. They were filled with pregnant damage." A career was born. There had been imaginings of it a year earlier in Penticton in an apple orchard, when I first felt the power of a woman's ass and had a spiritual experience. I felt I was intended to play Hamlet. I don't know why, but I felt it lay in front of me like destiny.

After about six months in Winnipeg, I left for Saskatoon to visit a friend in the same way as I had left Whistler, without telling anyone I was leaving and with virtually nothing. I never saw the Nordic beauty again, but through her, I had discovered the arts. Later I realized that most of the important discoveries in my life were made through the influence of women.

In Saskatoon, I found out about a theatre company that was just starting up, the 25th Street Theatre, and although they took a pass on a play I had written, they asked if I wanted to join as an actor, which I very much did.

The problem, as I saw it, with venturing further down this new path was still formidable. I was not an American, for one. When you are an actor, there is no success but that which is granted by empire. An American actor is always comfortable carrying a gun and flashing a smile, often at

the same time. They are born with confidence and are naturally tough, and the masses like their actors tough. I was never going to be tough. And I didn't have the right face, one with the power of a New Yorker's. People would learn that I was from the middle of nowhere, some desolate corner of some desolate province. I felt I would be destined to be a clown, cast forever on the lowest rung of the artists' food chain.

Still, I aspired to be a tragedian. I saw the profiles of great actors like David Garrick, and although I was cut from a different cloth, I knew I had to be committed if I was going to be like them. I imagined Nell Gwyn, King Charles II's mistress and one of the first English actresses, crying out to the badgering crowds that had mistaken her in the street for the ruler's Catholic mistress, the hated Duchess of Portsmouth: "Pray, good people, be civil. I am the Protestant whore." Gwyn was not who she appeared to be.

As a boy, I had been enamoured with Marlon Brando, had admired his godlike ability to transform suffering into beauty. No one could take a whipping like Brando.

DALLAS RULES

I was born to please. This boy who watched women working in the kitchen. I would entertain them while they prepared food and cleaned. Mostly, I just wanted to make my mother happy. Deeply religious and worried, she would hum bits of hymns to herself as she scrubbed and took care of our family. I longed to transform her sad songs into pleasure.

When I met my future wife, I felt compelled to rescue her as well. She was unhappy in her relationship and had an empty, desolate centre. I wanted to plant myself in that darkness like some bright rose. The bloom lasted a season; I was no lasting answer for her, as she was not for me. In the beginning, you always feel what love can do for you; later, you look for what it has not yet done. I learned that we love not by choice. We serve by choice. Loving belongs to another order.

❋ ❋ ❋

My first visit home after becoming an actor, I'd brought a young actress with me, and my mother had treated me in an unusual manner, as if I was a sinner in the company of a strange and fallen woman. My mother found fault with my boots, jeans, hair, even the way I sat on the couch.

My present girlfriend was from a different forest, and I knew better than to bring her home, but I did use her credit card to rent the car. One of those weekend deals. I planned on driving straight to my parents' place in North Battleford, Saskatchewan, where they had moved to be near my eldest sister. I planned on parking, then walking everywhere, and returning the car without putting on any major K. It was 1980 and I was thirty years old, and I had become the artistic director of the 25th Street Theatre in Saskatoon.

I badly needed my mother's home cooking, and I was determined to act civilized for the family, to put my best foot forward. Make a better impression than before.

Pulling up to the lodge, it looked like no one was around. They might be at the co-op, I thought. I found my mother had left a note on the front door: "Hi Son, I'm in the main hall playing recorder. Bet you didn't know I have talent, too." The main hall was in the building next door where they moved you when you couldn't look after yourself. I thanked God my mother and father weren't there yet.

I pushed open the doors to the lobby; the hall was around the corner. The room was groaning with recorders, like an organ stuck playing the same note, and I was

astonished at how fast and hard my heart was beating, worse than in the moments before I stepped on stage.

"Where's Mom?" I wondered, then suddenly she was turning the corner, coming straight at me. She was smaller than I remembered, wearing a flowered dress of many colours. A blue plastic pearl necklace peeked through a matching scarf held by a gold clip. Her hair had a goodly amount of black left in it, and she wore it the same as ever. My entire life was blessed with a mother of one hairdo.

She walked fast on her short legs, smiling, pale, and fragile. She was glad to see me. I was flooded with feelings, and with them, guilt followed hard behind. But it was time to small bucket the guilt, and as I bailed, I wondered why I hadn't come to visit more often. It wouldn't have killed me. This was the remarkable woman who'd given birth to me and six others. I fought the urge to hug my mother. That would be way too much emotion for her. It was time to shut down the feeling pumps.

When we got back to the small apartment, we found my father napping. I collapsed on the couch, and my mother went to work in the kitchen. She was firm in her actions. Her son needed hot soup and some of her homemade coleslaw. My father heard the ruckus and popped out from the bedroom, his thin grey hair mussed on the pillow side. He still looked mighty strong, though some softening had set in.

Knowing of my father's special stash, I played the actor, cleared my throat, sat up straight and gave a resounding

performance of a good cough, a short running up and down the scales. I worried that maybe I'd laid it on a bit thick. The chest thumping with my fist at the end was a flourish any mediocre director would have cut. But my father would have nominated me for an Academy Award, and he lit out for the bathroom to find the precious liquid, the customized stuff my father's doctor made from scratch. It may not, in fact, have passed the drug laws of the time, but my father said it had gotten him out of a jam the past February.

The old man passed the bottle to his prodigal son, who received it with ceremony befitting a first Oscar win. I held the bottle aloft, respectfully. Its glass was brownish, with white paper labelled in a handwritten Biblical font. I had a drink and then had two more quick hits for insurance.

As I disappeared into the couch, I felt a sense of well-being that had been absent for some time. I was reunited with family, comfort food, and the best medicine north of the Souris River, home to my ancestors. I felt true happiness.

My mother stood waiting for the soup to heat up, eyes transfixed on the plate-glass window. She spoke in a far-away voice, a voice that carried the knowledge of countless prairie winters. She was hypnotizing me with it; her mission was to hold me captive on the couch. She stopped time with the words "Cold, windy, blustery March ..." and then shuddered. March, yes, my birthday was coming on.

I sucked back another slug of the cough syrup, and it hit like a load of bottom-feeders, gut-punch alcohol with a

creamy aftertaste of opium. I knew my drugs from experience and smiled at my father through the coughing. "Has a good finish to her, Dad." You'd never want to be too far from this bottle, I thought. This was a product you could sell on any street corner. Does the old man know what's in there? I wondered. My father waited for me to hand the bottle back.

With one hand, I propped up a pillow for my head, stretched out fully, and could feel my conscious mind dimming, an enveloping relaxation, starting from right behind my eyes. My ears twitched with pleasure.

My father snapped the lid back on the magic potion and headed to the washroom. "That stuff will grow hair on your chest, young fellow, and it will knock the daylights out of that cough," he said. My mother asked if I wanted to watch some television. "Turn it on," I answered, knowing it was what she wanted to hear. I hated television but also knew I wasn't long for the world. The tractor liquid was pulling me, original sin and all, into a soft pit of feathers. My mother perched close by on the chair with the footstool, historically my father's chair. I knew there would be hell to pay for that trespass.

As my mother rested her small neat feet on the stool, my father spotted the outrage from the bathroom door. He stared at my mother's legs and made a slow beeline through the living room, like a bulldozer pushing a forest back. My mother pretended not to notice as my father plowed through to the bad chair at the end of the couch,

bumping her legs to the floor. A short victory, for my mother's legs were quickly returned to the footstool. The look on her face dared him to try the stunt again.

As I began to lose consciousness, my mind slurred to itself, "Dad's pissed and Mom doesn't care. Feminism has come to roost in North Battleford. I then fumbled to brush over the awkwardness. "How long have you two been married?"

My father spoke with grave certainty, "Over sixty years."

"Sixty years and counting," my mother added.

Fading, I thought to myself, These two might actually hate each other. I locked my eyes on the painting of a waterfall that had hung for an eternity above the green couch, or at least since I started Bible school, blinked twice as I recalled with clarity where I was, happy with the bad art and the warmth of family, if you could call it that, and fell asleep.

When I woke up, it was dark outside. My mother was still in my father's chair, but I found a hot bowl of soup resting on the coffee table, bread and coleslaw riding sidesaddle.

"Eat up. Your ribs are starting to show," my mother said, her voice melting the strange anxiety that was whirling up in me.

"Where's Dad?"

My mother pulled her kaftan tighter as if there was a breeze. "Gone to bed."

I dipped the bread into the soup. "It's just you and me then?"

"That stuff knocked you out," she said.

"Yeah, but I feel better. Thanks for the slaw."

"You went out like a light."

"I needed some shut-eye, I guess."

"I watched my best programs," she told me.

I hoped I was venturing onto safe ground with my next question. "What are they?"

My mother fluffed her hair as if she was expecting a visit from a lover at any moment and didn't answer the question. "*Dallas* is coming on soon."

"What's J.R. up to?" I asked with feigned interest.

She responded with some pride, as if she was in on a secret. "No good at all."

"Is he getting a divorce?"

Delighted with her knowledge of all things *Dallas*, she said, "That would spoil it."

"You're right."

For the first time since arriving, I took in the surroundings, doing a son's accounting. Had anything changed? Were all the pictures and objects in their places? No radical shifts were apparent, and all remained stable. However, I noted there were new portraits of grandchildren.

"Your sister keeps all your newspaper clippings in that jar, if you want to look at them," my mother offered.

I glanced at the end of the couch where a bundle of clippings were stuffed in a vase, and I fretted.

My mother raised her eyebrows. "You didn't get too good a write-up on that last one."

"No, they didn't take to that one," I admitted. "But the audiences lapped it up like ice cream. Sometimes the critics and the audiences don't seem to be at the same show."

"We try and keep up with you."

"Thanks, Mom. You should see one of my plays sometime."

"I can't leave. Dad won't go anywhere. If I go, when I come back, he's like a post."

I sensed the delicacy of the conversation. "Not getting any better, huh?"

She spoke in a lower voice, saying what never should be said. "He disappears into himself. The coming back's so hard, it's not worth the going away."

With a certain degree of sympathy, I said, "That's too bad."

"I'm worried sick about him," she confided. "I want to visit the grandchildren, and he won't budge."

I made what I thought was a practical suggestion, knowing she would never act on it. "You should go alone. He'll be all right. Don't they have people here who look after someone?"

My mother was insulted with my mentioning this next stage of retirement. "We're the youngest of the lot. We're the spring chickens here."

I tried pleading with her. "We need to get dad a sitter. You should be travelling more."

"He won't allow it." She was telling me the discussion was over.

Knowing my advice was empty and my mother was stuck, I tried to get on her good side again. "This is the

best soup and coleslaw I've eaten. You've outdone yourself this time."

"I'm glad you like it," she said. "Sometimes I lose a step or two and have to think about how I used to do it."

"How's everyone?" I asked, glad to have changed the subject.

"Everyone's pretty good. But flu's been going around. I guess that's what you've got."

I blew my nose. After all I'd put up there, it was nice to give it a break, have something finally flowing the other way. I felt my sins most when I looked at my lovely mother. I wished I'd included her more in my life. But how do you repay the love of a good mother? I wondered. My mother was a believer, but she'd never been a judging person.

On the farm, the best days were Saturdays when my mother would make cinnamon rolls and wax the floors. My sisters would kick off their shoes and slide in socks all through the house polishing them. The smell of fresh baking and floor wax mingled with the laughter of the four girls waving sugar bread in their hands. I missed the farm life, and I remembered that the only time I'd seen my mother cry was the day we abandoned the farm. I could see now how much life that place had given her. She had watched seven children grow up there, and I worried I might be the only disappointment in the bunch. But wretched self-examination was a burden I carried like the plague.

My mother's voice went up an octave, which always meant she wanted to have a more serious conversation.

On one matter in particular: that perhaps her son didn't know the comfort and companionship of Jesus. I sensed we might be heading into dangerous terrain. "We got a new pastor," she said.

The black sheep stacked his bowl and plate with his spoon and fork, looking busy. "Oh yeah, how's this one, Mum?"

His mother wasn't fully decided. "He's pretty good. He's not four square on everything, but we'll bring him around."

I moved to the kitchen with the dishes, kind of hoping my mother would proceed no further on the topic of religion if I got cracking on the chores, but I made the mistake of saying, "He's got some funny ideas, does he?"

My mother sang in response as if performing an aria, one I was sure she'd sung the refrain to in more than a few church meetings. "He talks a lot of metaphors and symbols."

On went the sink tap, with the hope that perhaps the flood of water would wash my sins clean, but my mother was hoping for a general discussion and put out the feeler: "I'm praying for him."

I felt the line in the sand. Once metaphors and symbols came into play, the cast iron literal interpretation of the word and the furnace blast of hell were not far away. I knew where she was going, and my radar was on full alert. Church talk in the home sector, all guns to their stations. Find the nearest shelter, for at that point everything becomes a black-and-white film. The accents are British, and the background is London. I'd seen this movie before.

My mother sensed there was resistance ahead. She wanted to lock in her son's salvation, and she wasn't sure how much time she had left. Jesus could come for her tomorrow. Tentatively, she went on. "There's a lot of new stuff creeping in."

"Don't I know it, Mum," I replied. "There's new stuff creeping in from everywhere, from behind every bush."

I was saying any nonsense now. I dropped my spoon into the sink with a clang, hoping the bell sound would signal the end of the round. I had lived my life avoiding confrontation, especially with my mother. But that night, my mother was tired. Too many lonely nights and prayers down on her knees. She sensed that between the coleslaw and the coming Rice Krispies squares the battle would not be won this time. Her abandon-ship voice eased back from Christian soldier to loving mother. "You want any more?"

I skulked back to the couch knowing it was safe. "I've about had the biscuit—thanks, Mom," I said. "You're the best in the West. What's on the other channel?" I changed the topic, wanting to give the rest of the evening over to my mother.

A sad tremor crept into her voice, sensing an opportunity had been lost. "Something foolish I guess."

"Well, let's watch it," I said, hoping to offer some consolation. "You think Dad would mind if I had more of what he was passing around?" As I passed her on the way to the bathroom, she slapped me on the arm. "You got better

colour now." It was time to put the Bibles away and play by *Dallas* rules.

At the bathroom door, I looked back to see my mother flipping through the channels. There was both a great love in me and a sorrow, and I felt as if I was holding two truths in my heart. I wished I could take my mother with me and show her my world, but my father would die without her.

As I fumbled for the cough syrup, I imagined my father taking smashes in the night. Then I heard my mother laugh at something from the other room, and her voice made the world seem safe. I thought, If there is any good in me, my mother put it there.

AN ACTOR PREPARES

An untrained actor playing Hamlet is faced with an almost insurmountable challenge. If you injure your voice, you hurt your most precious instrument. If you panic, you make everything worse—and I was panicking. I'd been told that Hamlet shakes the foundations of the actor in the role, and for me, the madness was becoming real. To make matters worse, this Hamlet had inappropriate feelings for his best friend's girlfriend. Clarke Rogers was the friend, and also my director in *Hamlet*, which Toronto's Theatre Passe Muraille was staging for the 1983-84 season. Rogers was most attentive to his girlfriend when he was being unfaithful to her. The girlfriend, the theatre critic for the *Globe and Mail*, knew this and was close to returning the favour. It was going to be a performance with a dangerous subtext.

The three of us played in cafés and bars and around Rogers's table, talking, filling up hours with art buzz as

people in their early thirties did then. It was euphoric when the three of us burned through the Toronto nights. We were all equally ambitious, but I wanted more than my fair share of the pie. I was playing with an intoxicating fire. The critic made clear it was my attention that made her life with the director possible, and I knew that was something no one would understand when judgment day arrived. When the critic drank white wine, her French Canadian accent would creep into the fragrance of her. It was a charm that worked the deepest part of the mine. I was a farm boy from Saskatchewan, where they pretended to hate the French, but the truth was nothing is more attractive than that which is forbidden.

When I shared my first cab with the critic, everything was sexy and thrilling. Even her name dazzled me: Carole Corbeil. I'd seen the name many times in the *Globe and Mail* when I ran a theatre in Saskatoon and found I had a bad case of envy in my prairie outpost. It seemed that being in the arts was rewarded in Toronto, and I hungered for a cultural life, but I felt ignored—an ordinary Canadian malaise. So the critic's writing was my invitation to make the move to the Big Smoke. I had entered the world of theatre as a bridge to film, but her reviews made theatre shine as its own destination.

We were drinking white wine in a bar on Queen Street, waiting for her man. I was falling into her eyes. She had a smoky look and a low melodious voice, and I liked the forgetful way she held the stem of a wineglass, the way

she smoked only an inch of her cigarette, but I was afraid of her intelligence.

She'd grown up between two jealous fathers, an English Canadian and a French Canadian. Her mother was a model who divorced the French father and married an English doctor from Westmount who was two decades her senior. Carole had learned English at her stepfather's table, and her new older English stepbrothers were skilled at mocking her French accent. She said her French father made her feel loved but unsafe; her English father made her feel safe but unloved. Her French father was short, and her English father was tall, and because of this, Carole told me that she was forever trying to win the approval of tall men. She'd married an American architect she'd met in Cape Cod as a teenager; later, she'd moved to Toronto with him where he helped with the design of the CN Tower. After buying a small cottage on Ontario Street, the marriage had failed. She had begun an affair with a poet across the street.

She told me that every pleasure for her meant a betrayal to someone else, that she was able to remain monogamous for three years, then her attention would wander, though not necessarily her loyalties. And she wanted a baby. She was looking for someone who wasn't threatened by that, and she wondered if she had found that person in my director. "He has a fine analytical mind," she said.

Time passed. Rogers was not appearing, and she lost enthusiasm for her subject, so I found myself sharing my life story. I was ashamed of it, but I did hope it made me unique.

I'd ridden a horse to a one-room schoolhouse on the prairie, the only child in grades one and two. I told the critic that whenever my blonde teacher leaned over to check my spelling, I got excited. There was something about the tips of her tobacco-stained fingers I liked. The way Carole smoked reminded me of my first teacher. I'd come to connect the smell of tobacco to worldliness and sexiness.

I explained how I had travelled to Europe, where I'd met a blonde Dutch woman in Spain who spoke English like an Oxford grad. She was a couple of years older than me, and I lived with her in Utrecht for about six months. During this time, she'd go off the pill and say she would not love me further, that our sex could not continue. But she'd change her mind, and then there would be sex followed by tears, the swallowing of birth control pills, and she'd become violently ill. After six months of falling in and out of love, I moved on. I took a bus to the airport, and she chased the bus in her bare feet. I would never forget that image of her, and often I wondered if maybe she did love me after all.

At the end of my story, I ordered another carafe of white wine. I'd meant my story to be an explanation as to how my life led me to becoming an artist, but I knew it somehow sounded more like an invitation for sex. I had exposed myself and was far over the line with my director's girlfriend. During my monologue, her eyes had misted over, but I couldn't read her present state. I sensed that I'd turned her into a good listener, and that she was not really eager to play the role, but I didn't want her to go and I didn't want her

to think about her missing boyfriend. I didn't want her to feel any embarrassment over what I'd said. I felt honoured to be with her, so I steered the conversation to her writing, how she had fed and taught me in that small prairie city, and how her take on art inspired me to come to Toronto to learn more about my chosen craft. She warmed up to me when I focused on her work, told me almost no one talked about her columns, that a public act like writing in a newspaper is isolating. That she was hungry for connection. That exposing herself every week tortured her. That she entered rooms filled with artists and felt chills coming from all corners and did not know why. She would wonder if she had offended someone. Or had she withheld praise? She told me that what she then craved was the privacy of writing a novel, so she could fulfill her lifelong ambition to write without worrying about excoriating others.

After she told me this, she looked frail, unloved, undernourished, and vulnerable. She wanted to leave. I offered to buy cigarettes. We stepped out to the street, and she appeared distracted. I dashed for the cigarettes, and when I returned, she asked to share a cab. She was going home, said maybe the boyfriend would be there. Before I responded, she waved a delicate hand and a cab screamed to a halt. I watched her slip effortlessly into the back seat and was moved beyond measure. Her movement was a thing of beauty, and all I could do was try to match her nonchalance.

Once in the cab, she looked deep into me and I willed myself not to look away, but feared what was in my eyes. I'd

played the fool. She must know that I want her, I thought. And for the first time in a long time, I didn't feel lonely.

When we arrived at her place, she thanked me for the conversation, told me I had an unusual streak of kindness and that she thought my mother must have loved me very much. For a moment, she rested her head on my chest. It was the briefest of gestures, yet somehow significant. I felt rewarded, received, included, valued, and understood. The touch of her head, her curly hair against my chest, lit a big fire that would never go out.

* * *

Clarke Rogers had made his decision. *Hamlet* was first on the docket. As the actor destined to play the Dane, I found being cast as the prince appealed to my vanity, but I also knew I was being led to slaughter. However, I couldn't help but love the man who'd asked me to be his Hamlet, so I hid my feelings of embarrassment behind a pose of humility.

The casting had been done in the springtime; *Hamlet* would open in the fall. I had been hired to spend the summer doing another play at the Blyth Festival, learning the lines to *Hamlet* in my time off. Carole would be spending the summer seventy kilometres away in Stratford, embedded in rehearsals for a Shakespeare play, writing an insider arts journal for her newspaper. Clarke Rogers remained in Toronto. Without the attendance of her boyfriend, and my director, Carole and I spent our first evening alone together in Stratford, on the patio of an English-style pub

by the bucolic river with the swans. I was shy and afraid of the beautiful critic, but the wine helped with that, and the passing hours drew us closer. We made a fateful decision together and rented a room.

That first night laying in the oppressive humidity with Carole, she slept well as I cradled my arms around her, as if I was holding a child who'd washed up in a basket. She felt smaller and younger in the dark, and at one point she cried in her sleep. I was more afraid than I'd ever been, but certain that I was intended for this woman. She filled me with dread. After all my longing and anticipation, I couldn't wait to get away from her, and I wondered if I was feeling loyalty toward Clarke or cowardice. I loved her but could not betray my director. Especially not before the coming rehearsal for the tragedy of Prince Hamlet. The ghost of the king might come for me.

I bought a motorcycle and spent the summer living on a farm, wandering the verdant fields reading *Hamlet* to the cows. In the evening, I'd drive my bike to the nearby swamps, turn off the engine, and watch the light fade while smoking cigarettes and listening to the frogs. I was searching for Elizabethan rhythms, imagining myself living in rural England. By the end of the summer, I was quite mad; once fall arrived, it was a relief to return to the city and begin rehearsal.

Back in Toronto, I ran up subway steps knowing the set would have many stairs. I wanted to be able to cover them with quickness and confidence. I lived on smoked trout,

capers, cashews, and champagne, and danced for hours to reggae. I never stopped moving. I would have to survive three and a half hours of speaking poetry, fighting with knives and swords, before finally dying. I was fitted for the black suit.

Along with the other players, I transformed the rehearsal space into an enchanted forest and a castle with hardwood floors and white columns. I was falling in love with a play, and there was no bottom to its depths. After rehearsals, I would remain in the room alone, running in circles through the empty space shouting verse. *Hamlet* haunted me.

※ ※ ※

My unconscious was a splintering crack down the middle of the wood. I was busy in the castle of the self, turning Clarke Rogers into both the stepfather, Claudius, and the father, King Hamlet, at the same time, and I was wondering if my own guilt for loving Carole was causing me to demonize my brilliant director. Was I casting Rogers as both a victim and a villain because of the unholy feelings that grew daily? These feelings were not good, nor could they come to any, but the cards of fate had been dealt and I was already on the ramparts.

I was also confusing Carole with Ophelia. She had become my secret audience and could trigger the alarm that might set the castle on fire. Ophelia was gentle, fair, and vulnerable—the story's virgin sacrifice. Her thin neck led to big eyes that looked away when pushing against the

patriarchy. Hamlet was grooming her to betray him, and he laid it on thick. He would be regarded as mad, which suited him; there was no question, he was something of a royal prick. If his advice to Ophelia were followed, more nunneries would have to be built.

Ophelia entraps Hamlet while Claudius and her father, Polonius, spy on him from behind the pillars. Carole watched *Hamlet* from Rogers's side. I wondered why Shakespeare hadn't focused more of the play on Ophelia, wondered if something more than letters had passed between her and Hamlet, as had between Carole and me. But, of course, the Prince kills Ophelia's father and contemplates doing the same to Claudius—or was it my director?

Hamlet did not seem to know much about love, and I felt I knew more. In Elsinore, weak men wrote love letters and sighed. In Toronto, *Hamlet* set the tiger loose, and madness was the ark that would carry me through the flood. No one dared fuck with a mad prince, not even a director. It was time to impress the dead father, King Hamlet, my imaginary friend bound in chains. There was only one way. The director must die. I meant Claudius. But first Hamlet's mother, Gertrude, had to be confronted. Her unholy marriage bed in which she slept with Hamlet's stepfather was stained: "The funeral meats did coldly furnish forth the marriage tables."

My stepfather/director was on his way to the lake of fire, sins unconfessed. Hamlet would no longer be gentle and loving. If he did not skin the pretender to the throne, he would be going to hell with him. I wanted to be good in

the part to impress my director, but I equally wanted to become my director, replace him. It was a great action that required sacrifice, and it was time to set the world right. It was time to gut Claudius.

Rogers had told me that when I held the dagger in my hand for the monumental "To be, or not to be," I needed to remember that it was not a prop, but a weapon intended to kill humans. There were tough questions to answer first though. Was Hamlet going to use the knife to kill himself? And if you take self-murder seriously, have you set yourself on the road to be a killer? If so, was Hamlet hunting himself? Was he simultaneously the predator and the prey? When there is murder in your heart, have you already committed the deed in your mind? Was Hamlet unable to register in himself the corruption he diagnosed so clearly in others? Should Hamlet's talk of suicide be taken seriously? Is he just another young person who pretends to engage with the prospect of self-murder, because he is attracted to the image of himself disdaining the world? I recognized myself in all the themes. That is what makes the character modern, I told myself.

The concept behind the production was more of an open question than anything this actor could dream up. Could an untrained Canadian farm boy play the world's most famous prince? It sounded crazy, and it was. I knew if I disgraced myself, there would be no coming back from this experience. I memorized the atmosphere of the play by listening to a four-sided cassette recording of a renowned

actor from London's National Theatre, learned there was a mood to each of the acts, and felt the language in my mouth radically alter me. I needed to ask myself how I could make this performance something even more special, something that everyone who saw it would remember.

If I get with Carole, would that be sufficient unto this play? I asked myself. Would that make me a better actor? Raise the stakes? Lift the whole project to the next level? Is there any betrayal greater than what I am contemplating?

Rogers had curly blonde hair, was rakishly thin, blue-eyed, a graduate of Upper Canada College, a not-quite-member of the ruling class. His father had been a doctor and lost the family fortune, or what was left of it. His mother had died from smoking, and there had been no doubt Clarke Rogers was his mother's boy. Women respond to that and so do men. I felt a deep kinship with Rogers over the lost fortune. My family had never been wealthy, but they had lost the farm.

Rogers was smart and provocative, just as you want your director to be. And it was impossible not to adore the man who believed in me, who would trust me even with his girlfriend.

These were the early days of rehearsal, and I was in awe of the world that was being constructed around me. I'd never felt more power in a room. The company created their Hamlet in the detailed manner in which they approached me, the actor. I needed only to look into my fellow players' eyes to know that I was their prince.

* * *

"You can't be wise and in love at the same time."

"Who said that?"

"Bob Dylan," I replied, then told myself to stay on message. I was on the radio and had to lay on the charm, at least those were my words of advice to myself. I was doing publicity for *Hamlet*, for my theatre's *Hamlet*.

I took a new tack. "Something about playing Hamlet signals shame. It begins when you agree to do it. You ask yourself, Why did I want to play this part? What does it have to teach me, other than failure?"

The student interviewer looked worried, glanced at the producer in the booth.

"I discovered from the experience, that the play is really about sticking with the plan. You have to stick to the plan, but Hamlet can't. A girlfriend once told me I would never get anywhere in life until I learned to stick with the plan."

The interviewer leaned back from his microphone. "What was the plan, marriage?"

"No, it was more mundane matters, like which restaurant to eat at, what wine to order."

"Let's get back to *Hamlet*. What drew you to this play?"

"You see those black-and-white photographs of past Hamlets, and there's always the prince and the skull. Who doesn't want to talk to a skull? It comes down to creating the illusion of talking with a ghost, your father. We all grow up in the shade of our fathers, and when your father is a

king, there's going to be more than enough shade around. You have to be able to spook yourself as an actor, make your own hair stand on end. Make the skin tingle. Hamlet's intellect, Hamlet's charm is unrivalled. He's arguably history's most interesting literary creation. So what can a farm boy do with a part like this? The language I learned was boilerplate Bible English. That's my native tongue. I memorized the rules, and the threats. The poetic psalms and proverbs were not often on the preacher's menu Sunday morning. Hamlet is Jesus wearing black. I know, I'm digging a pretty deep hole here."

I lit a cigarette, and the interviewer pointed to a no smoking sign. I abandoned the smoke and went for broke. I saw the producer in the booth, signalling something.

"Hamlet's words are the most dark and beautiful a human can speak. I feel like Shakespeare is telling me something important, and it's my job to pass that on to the audience."

"What would that be then? Specifically."

"That other people are not as bad as we think they are, but all of us are worse than we know or will admit to being."

The interviewer looked like a man before a car accident. "Oh, really."

"Yeah, Claudius probably didn't grow up thinking he was going to pour poison into his brother's ear and kill him. And then fuck the man's wife. Sorry, are we allowed to use that word on the radio?"

The interviewer put his hand over the mic and mouthed "No." Then he covered the whole business with a laugh. "It's

university radio, happens all the time. With a background like yours, how did you come to acting?"

"My mother was a spiritual woman. She came to Jesus by laying her hands on the radio. I came to acting the same way. Well, it wasn't a radio. I was in an orchard in British Columbia, in Penticton, in the summertime. It was like California. The light was fading. It was the magic hour. That's what they call it on a film set. The hour before the sun disappears. It's when beauty comes most alive. When Marlon Brando directed his one and only film, he shot the whole film in that light. Naturally the film went way over budget. What was my point? Sorry."

The interviewer leaned in close to the mic and whispered, "Ah, you were about to tell us how you came to be an actor. Your mother came to Jesus by laying her hands on the radio. You said it was the same for you and acting."

"Oh, yes. There was a girl in the orchard. She was from North Vancouver. She had the whitest teeth of any woman since the Garden of Eden. She was as perfect as an apple. I laid my hands upon her. I won't tell you where. But I had this powerful sensation, stronger than anything I had felt before. I was intended to play Hamlet. You're going to think I'm crazy."

Whispering again, "Try me."

"It was like Bethlehem, you know, I felt a baby was going to be born."

"With this girl?"

"No, after *Hamlet*."

There was a glass of water beside me. I took a sip and fought to bring my emotions under control.

The interviewer saw the possibility of me crying and quickly changed the subject. "Did that really happen about putting the hands on the radio, or is that a—"

"That was no metaphor. There are no metaphors on the farm."

"Amazing. What about your father?"

"Once a year, he'd need a good hug, so I'd give it to him. I had no problem with that. Like I said, it was a once-a-year kind of deal. Church was every week and that was much harder, but Hug Day…"

There was a long pause. The interviewer either gave up on me or had run out of time. "Is that about it then?" he said.

"I think so." I nodded and couldn't wait to take the Dane outside and give him a good beating.

"Okay, good luck. Thanks for coming down."

Hamlet was already out of his chair. "Thanks for having me."

I headed out past the university limits, walked for a long block, and then broke into a run. I remembered running everywhere as a boy, and that I'd always have a pigskin stuffed under my arm. And after sneaking into *A Hard Day's Night*, I had imagined myself a Beatle running away from female fans. But after the interview, I ran from the shame that chased me after the exposure, and the shame brought on the desire to self-harm. Racing down into the underground malls of Yorkville, I was headed home to do

a line, and Hamlet also needed a toke. He was having a hard time controlling his emotions. I thought that if I kept running, maybe I could be home before I started sobbing. I then caught an image of myself in a newspaper box on the cover of NOW, the alternative weekly newspaper that covered news, culture, arts, and entertainment, and realized fame was about reproducing an image over and over again. I had a hunch fame was not what it was cracked up to be. I thought of the instructions I'd given myself that morning, the ones I thought would make me a better man: Make her happy. Yes, if you do nothing else, make her happy. Make the woman happy. Get married. Have a baby.

It had turned colder, the sun was below the trees, and winter was waiting to pounce. I got home to my twelve-storey apartment building, an all-glass tower, took the elevator, the hallway with the bad carpets, turned the door handle, went in, and from under my roll-out couch-bed, I retrieved a copy of an Ayn Rand novel. I sat on the stained couch with emotion trapped in my chest and throat. It had to come out. Come out, damned spot, I thought, even though the line was from the wrong play. I hugged *The Fountainhead*, one of the few remaining artifacts of my early life, as if I was hugging my younger self, as if that boy might save me from the adult I was becoming. An inner voice searched the past and looked to the future for meaning.

He regretted leaving that girl from North Vancouver without saying goodbye. He'd spent the day on her

lawn with her, the day the Americans landed on the moon. Her father had run from the house cheering, "History is being made," but the young man didn't seem to care much about the moon. He wanted to be somewhere far more intimate. He was searching for the feelings from the orchard, but he was unable to return to them. They belonged in that past paradise, his fake California. It was where her heart-shaped ass had spoken to him in a new language. When he'd asked God if he could have the girl's heart, he promised he'd serve His will eternally. His second wish was something more surprising: he had asked God to grant him Hamlet.

He tried to remember if things had ever been this bad. He was broken. Everyone was going to think he was the villain. Well, he would be, but he would be with her. He would marry her for sure. He had to signal that to the world. He would only cause this much pain because love demanded it. There was going to be homicide in the air. His director would be dangerous. He and Rogers would be trading lives. There was no going back. The actor felt hollowed out. He would lose everything, but he would have the girl. She would be worth his life, his career, and certainly his bad reputation. For the first time in his life, he understood what it was to play for keeps. He imagined the director lifting an axe and slamming it down through his oak desk. Rogers would have a case of Molson's and

then play target practice by throwing bottles at his head. The glass and blood would gather like rain at his feet. His director would say, "She's too smart for you." Smash. "You're an actor, you won't be able to keep her." Smash. Rogers would be drunk but speak the truth. The actor would wait patiently like a good schoolboy taking the punishment he knew he deserved.

I opened the copy of *The Fountainhead*, which I'd first read in my sister's basement after being kicked out of Bible school. She worked the night shift at what was then known as the mental hospital in North Battleford, and her home had been my refuge from the storm. I had two jobs: one was to be quiet through the days while she slept; job two was to get grade twelve under my belt, the only boy in my family with a real shot at it. I'd read *The Fountainhead* while smoking Rothmans and dreaming of glass towers reaching for prairie sky. It had fused ambition and sex into one thing. I saw myself with the critic in an apple orchard. My fantasy was a play that she and I would be acting in for a lifetime. It would be a play with a happy ending. Unlike all the other parts of my life, this one would be sanctioned by love.

"I think I'm pregnant."
"I know. Are you happy?"
"It's ours."
"I never doubted it."

"I know you miss him. You were wonderful together. The two boys from different worlds. You were partners. You finished each other's thoughts. Sometimes I wondered if you were both not a little bit in love with one another."

"Yes. He was a great friend to me. The three of us made sense. Do you miss your old boyfriend?"

"No. I don't miss him at all. I like being a woman again. I like feeling cared for."

"You are."

"Let's stay together forever."

"I'm tired of it all. I'm not going anywhere."

"Are you ready to be a father?"

"I can't wait."

"It's natural to be afraid. We won't be able to drink as much."

"I'm nervous about that."

"Drinking is bad for children. My parents were alcoholics. It creates havoc in a child's life. As a child, too much happens that you don't understand."

"I'll stop. I promise. I don't fear you anymore."

"I don't know why you ever did."

"You looked through me."

"I liked what I saw."

"You're too smart for me."

"Don't say that."

"I know. I have to stop putting myself down. That's over."

"Do you love me?"

"I love you. I've loved you for a long time."

"It took you so long to say it."

"I just said it."

"Say it a lot. I need to hear it every day. That's how the French are. We need to hear it. We're not prairie people."

"I'm not prairie anymore."

I'd read *Atlas Shrugged* in a gravel-pit weigh station, a four-by-four-foot room heated by propane. It was thirty-eight below and I'd read it through a three-day blizzard, and I kept getting headaches from the lack of oxygen. The book had galvanized me. I quit the gravel-pit job and stepped a few rungs up the ladder: gas jockey at an Esso station. That was where I'd first applied the principles of Rand. I'd barely gotten the new uniform paid for when I had an epiphany at midnight on New Year's Eve: I would never build a skyscraper.

Feeling chronic dread, I reached into the fridge for smoked salmon, dipped my fingers into the capers jar for that salty taste, and laid out a good rail for myself. I ran the water in the tub and felt like I was truly becoming Hamlet.

Carole had watched a rehearsal and had kissed my cheek with tears in her eyes. She squeezed my hand, while her boyfriend said, "Tell him how good he is. He doesn't believe anything his director says." She didn't have to say

anything; I saw that look in her. As if she'd seen a ghost. A ghost she wanted to be naked with.

"Make that woman happy," I told myself, repeating my mantra. "So what if she's taken."

Nicely buzzed, I stepped into a bath of hot water. I was playing Hamlet in a theatre I was proud of and my director believed in me. The cast treated me like I *was* their prince. The play had been cast with talented actors I admired; I felt I was the only weak link, living a dream that no one can earn. It was a gift unlike any I'd imagined. No wonder I was so afraid.

It was two weeks before the butcher's block: opening night for the Dane.

* * *

I was in recovery from opening night. What had been beautiful and right in the rehearsal room had temporarily gone missing. The incubator of the rehearsal space was long with low ceilings, hardwood floors, and windows down the west wall, showcasing the evening light and casting magnificent shadows. It was the perfect Toronto castle. It was a warm womb in which I had been able to erase myself and give Hamlet the house. Hamlet hid behind the many pillars and spoke words that were and had to remain secret, because one shared could get you killed. My transformation had an effect on the other players, and they had become as haunted as I was. They found their *Hamlet* as I did, one secret at a time.

When we were ripped from this safe haven and moved to the bakery and stable next door, once a munitions factory, we found a place where the voice disappeared into the room's upper beams. Everything became awkward. The theatre space was undergoing renovation; it was gutted and filled with rubble. The two-storey building of cement, brick, and steel columns had been opened up to create one large open space with a balcony. It was a magnificent location to stage *Hamlet* but not the right room to contain secrets. The transition from one space to the other was profound, and the audience arrived too soon.

The cast became real to me. I no longer saw my friends; they had become the real dark court of Denmark, and I felt uncomfortable with playing nobility, with the arrogance of power. I knew the audience would be fixated by a somnolent familiarity with the story, that their preconceptions would be like cataracts in their eyes. I had to pierce their assumptions and memories of great Hamlets of the past. The task would be to gather them all into the present, because my Hamlet was soft and humble, most confident when alone in the privacy of his mind, which was where he would share his truths with the audience. My Hamlet would intuit the audience's questions and answer them with Shakespeare's words. The soliloquies were to be interactive, like call and response. This was scripture that needed sharing, and I knew my only chance of success would be if the audience and I could experience the play together.

I had never known loneliness like entering a room as Hamlet, and it was difficult to face the three and a half hours of the play. It was a long time to spend in a dark universe, one of wall-to-wall secrets and death. On opening night, I was rupturing with grief, and it soon became impossible to separate Hamlet's doubts from my own fears. I was a riot of confusion. I stepped into the light alone, with a briefcase. My feet knew the stairs. I was dressed in black. It was the most terrifying moment of my life. I stumbled with fear, and the night burned like sand in my eyes as I watched my dreams carted out to the parking lot and set aflame in the presence of my most cherished friends.

The following day proved I was in serious trouble. Friends greeted me as if someone had died, and there was no question as to who it was. In the dark corner of a restaurant, the mourners came and touched my shoulder in ways that were meant to show encouragement but really expressed sympathy. My publicist worked part-time for Citytv and asked me to read another *Globe and Mail* critic's review of the opening performance before a television camera. I hadn't read it yet, but I suspected I was submitting to a form of self-flagellation. I meekly did as I was asked, failing in my determination not to show my emotions. Understanding the role of television, the publicist asked me what my feelings were. I recited the "to be or not to be" speech, something I felt Hamlet was actually faking, thinking that he had no real intention of killing himself. The television crew quietly left the scene of the accident.

The *Globe* had accused the company of a lack of solemnity. The critic wrote, "They were as children, sulking and kicking at the shins of the giant Shakespeare," but we had felt just the opposite. We had rehearsed the play religiously and respectfully, our hearts in awe of the great work. We felt like we were monks making an ancient wine.

A national reviewer, however, was positive, said the production "excavate[d] fossilized language, raised the play from the dead." But I knew the negative words would always be with me, that the praise would be harder to remember.

After the opening, I'd cried like a guilty man who'd been given a death sentence, refused to pose for a group picture, sulked like a child, like Hamlet, alone, half-crazy, plotting revenge. I felt the shame keenly and let the world see the hurt. I went on to give a much better performance the second night, but the damage had been done. I knew there would be half-empty houses from then on. The people who paid attention to theatre were only too happy not to attend another rendering of *Hamlet*. The world was sick of them. People were mostly interested if a new actor was given the chance to disgrace themselves. The honour of playing Hamlet is more in the breach than the observance. Still, I wondered if anyone ever refused the opportunity. I doubted someone could.

The reward was living in the magnificence of the play. I knew the opportunity would not come again. I was performing for my director's girlfriend; playing Hamlet was courtship for her heart. Carole came to watch rehearsal

many times; she would stand silently beside me after performances and sometimes briefly touched my arm. Once, she kissed me under the seating risers and whispered what came across as a warning: "This will change everything."

Rogers and I were close, so it was a betrayal to carry a secret love for his girlfriend, especially since the director did everything humanly possible to support my performance. Rogers spent hours filling my ears with praise. It was clear that my director was in love with his Hamlet. That made everything so much worse.

※ ※ ※

When *Hamlet* closed, I took the first available flight to Jamaica, where everything would hold fresh promise, where I could be innocent again. I'd landed at the airport in Montego Bay and was renewed as the plane door swung open and the heat and humidity slammed my body. I hurried to find a cab with a good sound system, bought a little ganja on the way out of the airport parking lot, and hoped to shed all the competitiveness, hustle, guilt, and tension on the drive to Negril, where I'd be staying near Carole and Rogers.

The road was a gallery of eyes that barely noticed my passing, but I saw them and they looked hungry. My impulse was to romanticize their lives, but I clung to my wallet and hoped my good intentions would take care of me, a common white man's dream in a place where he was the minority. I knew I was in a land that would give as long as I could pay. It was a white man's paradise and a bit of a Black man's hell,

and somehow I also knew the world was never going to recover from slavery, that you can't undo some wrongs, that the stain on white people would remain forever.

The closer we got to Negril, the more I felt a farm boy's innocence return. I'd begun to wonder where that boy had gone, so it was nice to see shades of him again. The power of Jamaica, for me, was that it filled some deep inner hole and hooked up my mainframe to nature. It was as if no matter how far I'd wandered, coming to this place was like returning to a home I'd never known.

I'd been to the country once before, with a girlfriend, and had stayed five weeks in a cottage on a beach of white sand seven miles long. I spent the days in the water and the nights dancing to reggae. I ate ackee and salted fish for breakfast, lobster salad for lunch, and jerk chicken for dinner. On that trip, I learned that when Jamaicans welcome a tourist into their establishment, they take care of them like they own them. A tourist becomes their property and they don't like anything bad to happen to what is theirs. This can be good and not so good. I had witnessed a boy killed on a doorstep with a speargun. A few hours earlier, he had been released from jail, followed a British rock star back to his lodge, and stubbornly knocked on his door, looking for money, probably for food. A night guard speargunned the rude boy down; before that, I hadn't known the hotel had a night guard. Afterwards, I saw guards everywhere, and the duality of all things in Jamaica became clear. In the early dawn, the boy's body was dumped in the back of a pickup

and driven off to his mother's house in the mountains. The killing was when I understood my own privilege.

Once I got to Negril, I had nothing on my mind except feeling good, so I rented a scooter, parked at a cliff-top bar as the sun was setting, and let the wind blow more of Hamlet away. It was a nice place to have a plate of fresh fish, watch the liquid air change hues, and listen to some reggae.

I was weaker than I had been on my last visit. When *Hamlet* closed, I didn't recognize myself. Our costume designer had had to alter the waist of my black suit many times as I kept getting thinner. At the bar, a Jamaican friend told me I didn't look so good. "You need to take better care of yourself," she said, then she sold me a half gram of cocaine for seventy-five American dollars, as if that was what I needed. As I unsealed the package, most of it dissolved into humidity, but I sniffed the residue and was rewarded with a surge.

Maybe a half hour later, a Jamaican woman sat down uninvited beside me, placed her hand on my thigh, and said, "You should check meh out." She had playful eyes and lovely skin. Everything about her melted my resistance. She was a young woman, perhaps twenty-three, and as warm as the Jamaican sun. She wanted me to pay for sex, which would make it a bit hard to continue with the innocence. When she said, "Check meh out," I realized that *Hamlet* had altered my relationship to words. I could crawl inside them like never before, and therefore it was a free fall into the Jamaican vernacular. At one point, I heard an old prophecy,

albeit with a distinctly Jamaican flavour: "When yuh born to hang, yuh nevah drown." That one spoke to me in a loud voice. It carried an inherent power-bucking courage when needed. And I liked the sweetness in "Ev'ry dawg hav'm day." I came to feel more at home with Jamaicans than anywhere else. I knew what it was like to be born into a British colony next to the American empire, so despite the obvious disparity, I imagined an affinity for the culture.

The Jamaican woman's name was Sharon. She wanted to buy a bed, she said; she lived at her mother's and had never slept in a bed of her own. They lived somewhere in the mountains. It was cooler up there, she told me, and people were nicer, and if I wanted, after she got the bed, I could come and meet her mother and be the first man to sleep with her in it.

Sharon pushed me to dance, and although I felt awkward, I gave in. Instead of dancing conventionally, however, she placed herself behind me and gently bopped her crotch into my tailbone through a languid recording by the Jamaican reggae and dancehall artist Yellowman, who had success on the global stage in the 1980s.

When we got back to the table, Sharon told me Yellowman had loved her for a time. When she first met him, he performed in her village and had to sing all night. When he'd finished his planned set and went to leave, he found that all the tires on his limo had been slashed. The crowd would not abide his leaving, so he sang another four hours while they slowly changed the tires. Sharon ran off with

him at dawn. Yellowman took her away on the Queen's Highway. Months later, down the same road, she abandoned him. She feared she was in danger of losing her life to him: she would lose herself; she knew how difficult it was to love the truly famous. Sharon made her hands dance in the air when she said "life," then held them to her heart. She was sincere and soft. There was no anger in her.

Coincidentally, I had had my own remarkable Yellowman encounter only a few weeks earlier in Toronto. I'd never done Shakespeare before, and Laurence Olivier had said the most important thing was to be fit. He swam. Swimming in Lake Ontario wasn't an option at the time as the water was poisonous, and I didn't like the chlorine in swimming pools, but if I smoked a joint, I could dance for many hours to Bob Marley. While doing just that, however, I'd badly injured my neck and upper back. You can't dance for hours without warming up first. Hamlet had been hitting a groove and the pounds were evaporating, but I may have been in the right frame of mind at the wrong time. I was haunting my own house, readying myself for the dark corners of the Dane. During one of my flights of ecstasy, I crimped. However, manic with Shakespeare and reggae, I could not find a way to rest, so I made an early fall pilgrimage through the Toronto ravines, limping for several miles to see Yellowman in concert.

When Yellowman appeared, he was in a golden outfit and had matching braided dreadlocks. As the evening progressed, I found myself chanting along to the song "Lost

Mi Lover," which was about running away with a woman named Sharon from Devon, and it seemed like a miracle to meet the actual Sharon from this song only a short time later. Yellowman's song was also pitched in a miraculous groove, and as I danced with the crowd and found a spiritual flow sufficient enough to counter my dark and terrifying play, the crimped neck and back pain dissolved into the morning dew. Hamlet was healed.

Sharon spoke of immigrating to Canada and said any help I could offer would be appreciated. I was anything but rich, even by Jamaican standards, and I had cashed in my RRSPs to come to her country and recover from *Hamlet*. And I was not really looking for sex, or a woman, excepting the critic. I told Sharon I was in love already, but that the woman was with somebody else. Sharon told me that was cool, said "nobody needs to know our business." I paid for the dinner and got ready to leave. It was going to be uncool to stay at the bar any longer.

Sharon followed me out of the place to where I'd parked the scooter on the Queen's Highway and asked if I would drive her downtown. She hopped on behind me, her warm body close, and sang a few licks of soft reggae in my ear. This was another side of Jamaica. As I said, my previous visit to Negril had been with a girlfriend. I offered Sharon a few words from *Hamlet*, something about the undiscovered country from whence no man returns. The night was feeling like liquid sex, and I wanted to punish Carole for being unavailable, so when Sharon tugged my ear lobe, I felt a jolt

of pure pleasure, alongside shame. I tasted her sweet breath as she said, "I know how to do it nice." Would this be sexual tourism, I asked myself, or would I be helping someone to purchase a bed? Carole couldn't expect me to be faithful if she wasn't going to be. Then Sharon whispered, "It's all right to feel good, mon," and her voice travelled down the Dane's chakras to Hamlet's final hiding place.

※ ※ ※

Carole plucked a beer from the cooler. She was wearing a tight yellow dress, her curly hair glistened, and her skin was browned and damp from several days of Jamaican love. She and Rogers were staying down the beach from where I was staying in a shack called No Vacancy; I spent most of my nights there. Darren, a college student, owned the place and had joined us one evening. He was a well-dressed gentleman, studied business in Kingston, and was home in Negril for the Christmas break. We drank mushroom tea, and Darren rolled a spliff of the finest mountain herb, which Carole called "bubble," because it made her feel effervescent, like she was in champagne mode. Darren and Rogers engaged in a conversation about the Trinidadian writer V.S. Naipaul. I had some interest in what they were saying, but I was high and kept my eyes on Carole and her yellow dress. She seemed more in love with my director than usual.

I looked at the sea, remembering her grey-green eyes under the seating risers in the theatre. It had been dark in

there, and it had felt like we were in the guts of a great pyramid. I remembered thinking that if I was going to take her away from her director boyfriend, it would have to be soon. She was waiting for me to make a move. I loved her, but I loved her boyfriend to almost the same degree. I remembered her words were clear and pointed: "Every act of love for me involves betrayal to another."

I wanted to tell Carole about Sharon, check the jealousy meter, but I switched tactics in an effort to impress her with my own take on Naipaul. "Naipaul visited prostitutes," I said. "He found it helped the writing, that they gave him energy. They were a kind of shameful muse."

Carole didn't understand the vehemence with which I spoke and responded, "I'm not sure what the equivalent for a woman would be."

I was embarrassed, shrugged, suggested an affair would be an equivalent.

She took a short draw on the bubble and said, "You have to ask yourself why shame is necessary at all—for writing, I mean. I hear in Naipaul's voice a man ashamed of sexual desire. The mechanics of sex embarrassed him. He'd internalized the Oxford don's hatred of women. Sex with a prostitute would be ideal. The mechanics handled by the other. Passion has no role in what is a simple exchange of money for services. Sex as a commodity, not an expression of intimacy, not when you're vulnerable as a baby. Ask yourself why lovers call out 'baby' when they come, why it's such sweet music when you're lost in something unpredictable.

Paying for sex is an attractive idea for a man. It removes performance anxiety from the equation. Services delivered require no more than a few seconds, maybe minutes. It's boilerplate capitalism, but is it good for women? I'm not sure what the consequences are for the woman."

I marvelled at her ability to speak in paragraphs. I sputtered, "Maybe the woman wants to buy something, like a bed or whatever..."

"Bed?" She looked puzzled.

"Where did that come from?" I said it for her.

"Yes, bed!"

"A woman told me earlier she wanted to buy a bed for herself. She's never had her own."

"Was she a prostitute?" Carole asked.

"She's a young woman who needs money."

"She offered to sell you a sexual favour?"

"Yes."

Rogers and Darren were laughing about something on the other side of the room.

Carole hung out one word: "And?"

"What do you mean 'and'?"

"Oh really?"

"Of course not, I'm faithful to someone important to me."

"How noble of you."

"Yeah, well, who knows how long I'll be able to hold out."

She passed the spliff to me, touched my knee, and looked into my bloodshot eyes. "Don't play games. You know what I want."

I looked at Rogers, who was changing a tape on the player. I nodded and sucked too hard on the bubble. Her anger sent her outside. Rogers pulled a beer from the cooler and handed it to me. I took it, but I was thinking about him making love to Carole that night. No doubt the mushroom tea would guide their way.

I excused myself and followed Carole outside to where she was smoking a cigarette on the beach. I lingered close, not quite touching. She said one word, "Triste," the French word for sadness. I then felt cold in the tropical heat. I understood how complicated things were. She asked if I wanted her to come with me right then. I wanted to say yes, but I didn't. "We can't be together until the next show ends," I told her. I wondered how many more shows there would really be.

She relaxed then, knowing there would be no immediate large and dangerous gesture. She stroked me with her voice. "You were a soft and brilliant Hamlet, unlike any other. Do you miss it?"

"I miss you watching me play Hamlet," I said, understanding that anything I did going forward would lack the excitement of the last few months. "But I feel lucky, like in my real life Ophelia has not drowned. She's not in a play, she's here, I can touch her."

"Are you ready to have a baby?" Carole asked. "I think we would make a good team."

I hadn't expected that one. "I would like to be present at the time of conception," I offered.

"I will cast you when the timing is right."

Then she said she would come to my hut the next day and I knew what she meant and it scared me. "I need a break from betrayal," I said.

She stared at the dark water for a minute, then went back into the shack. I walked back to mine sipping my beer, feeling empty. When would I get the courage? I asked myself, and then I repeated my mantra, "After the next show. One more show and the season ends. Then stick to the plan." Thinking about Sharon helped. I thought about her lips on my ear, and the exquisite pleasure of her tugging my ear lobe. I lingered on the thoughts and wondered if I would run into her again.

I entered my hut and lit a candle, and the mushroom tea sent shock waves of both pleasure and horror through my system. I stretched my hands across the breadth of the space and touched the two opposite walls. I wanted to crucify my conscience. I wept for my sins. I unconsciously began typing in the air. I remembered the satisfying pleasure and the purging that came from writing many hours a day, that writing had the potential to dissolve guilt, and that my best moments had been private imaginary ones, banging out secrets on an electric typewriter when I'd first written plays in Saskatchewan. I could smell the ink of the ribbon on the typewriter at Bible school, could hear the sound of a carriage bar return. I was going to write my own play I would act in. It would be called *Meh Tek 'way duh Queen from duh King*.

I sat down at the simple wooden table, moved the candle closer to a piece of yellow paper, and, channelling Yellowman, wrote, "You mek luv go and you mek luv stay."

THE
TSUNAMI

Spring 2000. I stepped through the revolving door and was overcome by the image of her; she looked so vulnerable. I had bundled her up more than she needed to be, had lacquered on the sun block, and ensured we wore hats, though it would soon be evening. She was even paler than before. The air outside was cool, the land dry and desert-like. The smell of garbage was overwhelming, and the ocean air smelled like a mixture of seaweed and burning tires. No one was swimming that day.

We walked unsteadily down a street of abandoned open-fronted shacks. It was off-season, and only weekends lured the locals out. We heard a mariachi band ahead, the music joyful yet melancholic. It was the only sound of life. As we passed the tiny café where the band was playing, we manufactured smiles of approval for them. They looked to be practising, since the place was empty except for a lone

woman sitting in a corner. I looked for a taxi, but there were none. Ahead lay the main thoroughfare that paralleled the beach and the Pacific Ocean.

We inspected the tall fence that separated Tijuana from the United States. It had hundreds of names painted on it, the names of those who had died trying to cross into America. It was both a monument to the dead and a warning to the living. The American side of the border was devoid of buildings and signs of life; it was a no man's land. We stopped at a bench at the top of a flight of concrete stairs that led to the beach, but we didn't attempt to go down. She was suffering more than usual.

We perched at the top of the stairs like two birds unable to fly. The sea made my eyes water, and Carole reached out her hand and I took it. She looked away and let the sky carry her somewhere, then softly spoke:

> I have a question to ask my sister. I want to see if she remembers when Mommy left us tethered in the backyard in Outremont like goats, when she put us in harnesses as toddlers and leashed us to the clothesline. I can still hear the squeak when I got to the end of it. I was forever trying to get away from my sister, but was always wanting to be with her at the same time. It was a pattern that set me up for all my loves after that. Later, our father sent for a gravel truck with a dump of sand, as he wanted to give us a sandbox to play in, but it just became a litter box for stray cats and we never

went into it. I wonder if my sister would remember that when Mommy left our father, she stripped the apartment bare, even took the light bulbs and the handles to the water taps. She was vicious in her leaving. Daddy came home at the end of his workday, and there was nothing left, not even the floater thing in the flusher tank. I remember him saying, "She never left me a slice of cheese, and I had to use the toilet as an ashtray."

Carole was broken inside after her parents' divorce. She joked that her French Montreal education and upbringing was "the full catastrophe," but she felt a tremendous loss and guilt for having partly lost her Québécois heritage. She was raised in a Niagara of Catholicism—priests, nuns, all the rituals of dread and beauty—but I found she wore the legendary Catholic guilt like stained glass in a cathedral. Well, perhaps more of a sexy dress. When her mother died, I felt the bottom fall out of Carole. She was then not only grieving the loss of her mother, but the life after her mother married into a rich English family. A glamorous and successful model, twenty years younger than her second husband, she was like a trophy wife who had to shear off the children to do the new job of making their stepfather happy. I knew the family history better than my own, for Carole had recorded everything, had kept a diary from early childhood, an astonishing narrative spanning four decades.

She spent years writing her first novel, *Voice-Over*, which was a semiautobiographical account based on her family published in 1992. The story chronicled her parents' divorce, her mother's hatred for her birth father, and was written in both French and English to give voice to what was then Canada's bicultural reality. Carole spoke about recapturing the memories of her childhood by writing in French, about the importance of recalling memory as a path to healing.

Her second novel, published in 1997, was about an actress, "almost famous and almost forty," who was cast to play Gertrude in an alternative theatre version of *Hamlet*. *In the Wings* was written during the finest period of our marriage. It was inspired by a day trip to a northern Ontario estate farm around 1993, when our daughter, Charlotte, was about seven or eight years old, a year before the fateful diagnosis. It was one of those dreamy leisure farms by a river, the sight of which was hidden from the property. Carole had peeled off her jeans and plunged into the cold and fast-moving water, forcing her way upstream against the current in her underwear. She was gone for the day while I covered at the farm, for I felt in my bones that it was important for her to get lost in her thoughts. She was herself almost forty years old, and she felt an awakening power, an energy as strong as the force of the river that ran against her bare legs. She thought of Hamlet admonishing his mother Gertrude for her vitality, her sexuality, at an age when he believed the blood should have decently cooled.

In the river that day, she felt outraged that Hamlet, and by extension the world, assumed that a woman in her forties should have lost her passion.

We spent the summers of 1995 and 1996 on Wolfe Island, while I directed and acted in a festival in nearby Kingston. She spent the days caring for our daughter and working on the novel, picking me up at the island's ferry dock when I returned from rehearsal. Sometimes we would drive to the far end of the island and make love in the car. She demonstrated that the Queen of Denmark wasn't anywhere near being too old for a bit of carnal pleasure.

There on Wolfe Island, at the headwaters of the St. Lawrence, I would lie awake at night, the screened window open, and listen to Carole recount the unfolding events in her novel. The river gathered force at that point, and as it passed English and then French Canada, it was kind of like a physical link to the two sides of her heart. The fragrance from the thick forest of lilac trees surrounding us mingled with the fresh air from the Great Lakes blowing east to the Atlantic. I could hear the way her native French shaped and informed her use of English, and sometimes she would speak in French to me, knowing I couldn't understand. She opened my eyes to the power of art and feeling, and it came to me that I was being created by her.

※ ※ ※

We got up from the bench overlooking the beach. I looped my arm under her shoulder, and we headed back to the

hospital. I fought a terrible feeling—that this may be the last time we would walk anywhere together. She felt an agonizing weariness. I pointed out the painted shacks and the bullfight arena ahead, where Carlos Santana had recently given a concert. Like a demented pop commentator, I critiqued the guitarist's last album. She said she admired the fierce sexuality in one of the videos, one of the few she liked over the years. I privately regretted all the time I had wasted watching music television. I half carried her past dusty and empty fairgrounds and, for whatever reason, noticed a Mercedes parked at the entrance and a jogger circling the site. The Oasis of Hope Hospital, a radical treatment centre for cancer, turned on its lights a short block away.

"I love you," she whispered.

I got her inside, made her comfortable, set her up with a book, stacked pillows, and placed the light perfectly, hoping she might want to stay up and read. I had learned early in our marriage to sleep with the light on, and I got to the point where I depended on the light throughout the night. It never bothered me. When she was happy, I felt safe. But that night, she was too tired to read, and she said she didn't know if she'd ever read again. I turned off the light and sat in the corner with the drapes pulled and watched her sleep.

Why didn't I fill my head with great literature? I wondered. Carole had read like she breathed, sometimes pulling all-nighters with a book. I then wished I'd spent more time holding her hand and reading aloud to her. Why did

I need more than that? Marriage is a long march, I knew, and after a certain point, one partner or the other is out of step. Marriage drains the swamp of unrealistic hopes, and as such is a lesson in realism. My wife was slipping away from me, and it was teaching me something important; I was losing the small daily wonders of the ordinary.

After some time, Carole stirred and opened her eyes. I reached to touch her. She'd had a dream and wanted to write it down. I got her pen and turned on the light. It pleased me to see her writing, as she had prematurely halted writing a new novel. She'd spent a summer at Oxford researching what was to be a book called *Imagining Jane*. I thought it would be her finest writing to date. I knew what it meant if she abandoned that work.

After a short while, exhausted by her disease and the effort, Carole put down the pen. The next day, she packed all her writing in boxes, telling me she was done, it was time to go home. She was burning down to her bare essence, and I felt love like I had never felt before.

* * *

Summer 2000. The day we left Toronto for a summer of healing near Lake Huron, the sky was a Toronto grey, a colour I was becoming fond of; twenty-five years in the city had changed me. I felt energized when the sky turned stormy and billowed with darkening clouds. The farm boy who lived in me then was in the tiniest Chinese nesting box, the one with the small mysteries inside.

On moving day, I'd driven back and forth to the farm near the village of Blyth twice, two and a half hours each way. On the first trip, the car was loaded with the organics, and squeezed in behind the driver's seat was a state-of-the-art juicer I was hoping would help save Carole's life.

On the second trip, she rode in front, the trip made more bearable with added pillows. Charlotte was stuffed in the back, buried in her burgeoning wardrobe. Now fifteen, she was to act in a play that summer about the Donnelly family, who had been infamously murdered about 120 years earlier a few miles from where we'd be staying. I had bought Charlotte a picture book with the full story, the same book I'd sourced years before when I'd acted in a play about the same family. I had the idea of reading her a chapter each night and that she could present a scene on it the next day. It would be something we could do together, and it would give her a head start on the play. I knew Carole didn't want the summer to be centred only on her health.

When we arrived, I bounced the car a bit too much going up the long driveway. Giant Manitoba maples lined both sides, leading to the Victorian farmhouse that had a tinge of Rockwell to it. Despite the circumstances, the mood in the car was buoyant and hopeful. Carole was having a good time, which meant I was, too.

The first order of business was to string a hammock between trees, a place to make Carole comfortable. I then set up a grand bedroom in the living room and something equally nice on the front porch. The plan was to ensure my

wife never suffered from isolation, hidden away in some far corner of the house. She was going to be front and centre and, hopefully, able to enjoy the summer as much as possible. At first, the plan was working. What was not working was her ability to eat food or drink the juice I made for her.

I organized lawn chairs on a field of grass between four overhanging willows, where Charlotte would present her scenes from the Donnelly saga in the evenings. Across the road, Belgian field horses grazed, majestic giants seemingly from another time. I decided it was a sign—I saw everything as a sign—and I remembered a Belgian pulling my father's Ford coupe, whose engine would not turn over. Belgians were good luck, I wanted to believe. They were watching out for the family.

Without her knowing, I watched Carole closely. She was walking again, joining in on things, and was embarrassed by the effort being made for her. She was rallying, I thought, or rather hoped. Recovery was around the corner, but I knew things could take a bad turn without warning.

The first day at the Victorian farmhouse, I had boundless energy and was hopeful. When Carole took her first nap, Charlotte and I drove to the nearest town with big-box stores and lattes: Goderich, a miniature Edinburgh. We were on a mission to buy linens and towels, rubber mats for bathtubs, and storage containers for vegetables. I settled into a safe speed with my daughter riding shotgun and going word for word with 2Pac and Dr. Dre in "California Love." Charlotte was good at riding the count,

clipping the words nicely, rapping about bomb-ass weed, pimps on missions, and being fresh out of jail. I thought that encouraging her to rhyme with rappers was kind of an equivalent to a father playing catch with a son, but this ritual also helped me feel like a cooler dad. When you're the father of a teenage girl, you don't want to lag too far back in the pack of coolness.

For ten years, I'd been driving Charlotte everywhere she needed to go. I was both a father and a chauffeur. From kindergarten onward, I sat beside my daughter's river of commentary. On this particular drive, she talked the gamut: the importance of having the right hairdo, the fragility of male egos, the limits of human patience with American pop culture, the injustice of a woman's lot, and finally the story of the Black Donnellys from the Lucan township. She was quiet by the time we pulled into the parking lot of the Canadian Tire. As I locked the car, Charlotte asked why the Protestants of Lucan hated the Catholics so much that they would kill an entire family, including women and children. I didn't have an answer, and as we entered the store, it began to rain.

Inside, I saw an attractive woman pushing a child in a stroller; she looked like a version of Carole from long ago. I hid my eyes from my daughter. I knew she was well into her own sexuality, and I wondered if she'd find a boyfriend that summer. I asked myself if I needed to fret about that, too, and knew I had to keep my wits about me. Fifteen-year-old girls, even when their mothers are struggling with

cancer, are vulnerable in all the usual ways, I thought, and I hoped my wife had given Charlotte that talk. I was worried, because my daughter was definitely a "looker," and I knew that rural males were notorious impregnators of young girls. Christ, isn't life complicated enough? I thought, as I searched for the aisle with the wooden bowls, thinking they were probably not the most bacteria-free bowls but that they felt healthier. And drinking and driving? I'd definitely have to tell her about country boys.

I began to churn with anxiety. I was now worried about Charlotte and also worried about how much it was going to cost to buy all the stuff we needed. I also had to learn dialogue for the play I would be rehearsing at the summer theatre the next week, and the theatre I was running in Toronto was short of money. I needed to meet with a banker soon.

Back at the farmhouse, I located a community nurse, one who'd worked for years on hospital cancer wards. In confidence, she told me that in her early days they gave cancer patients heroin; it worked so much better than its chemical cousin, morphine, but they'd stopped using it as a painkiller because it made the hospital wards vulnerable to attacks from addicts. At some risk to her career, the nurse advised me that if I had the ability to seek out heroin, I should do it right away. Do it for my wife. I made a secret pact with the nurse, and I was grateful to her for being honest with me. I did know where to get that kind of help, from an old friend from the '70s.

I couldn't stand to watch Carole's pain anymore, and I told her what the community nurse had said. I felt as though Satan stood to one side of me offering his hand to relieve my wife's pain and suffering, and on the other was the Lord offering good fruit and vegetables. I somehow needed to make a salad with these two powers. I made the extra effort to identify and locate organic produce but also decided I was going off the grid, telling myself, Fuck the medical establishment. Carole's nights were long and filled with bouts of unbearable fear and pain, and I felt helpless as Death stood in the fields outside our summer home, waiting.

※ ※ ※

There are things you regret doing even while you are doing them. This was one of those times. I saw myself from the outside. I was a husband and a father, whose bad or good parenting was rooted in sixties myths and culture. The way I'd walked in the world was a product of my time, and the time had encouraged a certain kind of fantasy. The world was changing for the better, and my generation was special. We were going to free ourselves from war and make love without religious restraint. It was a time when the mass depression over the horror of the 1950s was combined with drug-fuelled elation. The generation's rock stars and guitar heroes were writ large, representative of the time, and our generation identified with them, believed we were somehow like them. You didn't have to be famous to feel

famous, as long as you stamped your feet and made a joyful, often sexual, noise. I was a true believer in the fantasy and continued to live a secret hippie life, perennially holding a self-image of myself as some kind of rock star.

My old friend from the '70s lived above an art gallery in Toronto, and while driving in, I thought about how little the city had changed over the years and yet how much it had. I felt nervous when entering the dealer's place, but not once I got inside. He was a kind man, an expatriate American who held court with the city's finest chefs and lawyers, judges, corporate leaders, and rock kings, day in and year out. The wall-sized television was always on, tuned to the comedy channel, 24/7. The dealer never left his bed because he couldn't; he'd grown too large over the years. His home was stacked with Indigenous art from across North America and with every convenience; there was a video camera monitoring everyone who came and went.

Buddha on the bed had a blackboard tray where he laid out masterful lines of coke and heroin. Uptown and downtown. You could choose to go in one direction or to go in both at the same time. A wonderful confusion of feelings. I knew by experience that my nose would jam, that I was allergic to these powders, had been my whole adult life, but I accepted the short candy-cane plastic straw anyway, leaned over, and slipped a line into what was left of a nasal passage. It stung as I waited for the old familiar feelings of warmth and love and interest in my fellow man. I felt united with the Buddha as we talked about the madness

beyond the walls of the room, walls the Buddha would never escape.

The old dealer friend read my wife's books and was a fan of hers, and he agreed with the community nurse that sometimes heroin was the only answer. A phone rang and I listened to the dealer lecturing a delivery and contact man. "We're talking about a great artist here. This calls for something above average. This is a humanitarian act, an act of selflessness, and it must be taken care of immediately. And please refrain from stepping on it. I want the best, something noble, something pure. This is a chance for us to show our humanity, our opportunity to serve." The dealer hung up the phone, saying, "I don't trust him, but maybe he'll come through. If he doesn't, the almighty will strike him down, I promise you. And it's going to take an hour. You want to wait or come back?"

I knew the dealer would rather I leave and return. Others were wanting to make purchases, and Buddha had to keep his worlds separate. No one wanted to be seen in his apartment; *junkie* was a bad word.

I hit the street, looked for detectives, drove toward Yonge Street, feeling despondent and alone, weakened by guilt and ashamed. I wished my mother was still alive, wished my wife didn't have cancer, wished I was a better person. It was getting dark, and as the street lights turned on, I thought they didn't flatter my city much. Toronto was so uninviting after the Manitoba maples. There was a father pushing a little girl in a stroller on the sidewalk, and

I found myself saying a prayer for the two of them. I saw a woman hurrying by with a young girl in tow, hanging back like my daughter used to when I walked her to kindergarten. I thought about how children became adults and how adults do things they never imagined when they were children. Lost innocence was a fine theme for the night, I thought, so as I drove by a club, I thought I deserved to tuck in and cool down. It was damn hot out, and as I hadn't had a drink for over a decade, I thought maybe it was time to change that—which was all I needed now, I realized, a relapse. However, I did want to have a cigarette, though I'd quit smoking years earlier when my daughter was born. This was one time, however, when I thought I'd indulge.

I paid the parking attendant and hustled toward the alley door. I wondered about being busted, wondered if one of my colleagues or acquaintances would be in there, perhaps an actress I might have directed would be inside dancing, trying to make ends meet.

As I entered, the smell hit me and I gagged. Why do these places always smell like this? I wondered. They scanned me for weapons, and then I rounded a blind wall and entered the mosh pit of Delilah. A small voice from my childhood—the voice they'd brainwashed me to believe was the voice of God—said, "Never go anywhere they check you for guns," but still it seemed like a good place to kill a hot gap of an hour. I lit up a cigarette and stared, both appalled and entranced, as a lithesome, incredibly

fit dancer ruthlessly ground her behind into a customer's crotch. Once seen, never forgotten. The small voice screamed. I ignored it. My heart beat faster as I sensed a creature of comfort; a woman waiting in the dark by the mirrored wall just for me, I imagined. She had the dark hair and looks I'd chased my whole life. Blessed are the dark-haired women, I thought, for they reminded me of my wife. Or was it my mother? This was the wrong time for Freud, I thought. I didn't want to think. Disappointingly, the woman then disappeared through a black curtain, only to reappear again at the top of the stairs that led to the stage. Wearily, she rested her purse and a white towel on the steps. It was show time, perhaps not exactly a time to make dreams come true, but at least she would try to fake it. Seemingly resigned, she took a last few steps in heels that inflamed her leg muscles, and she made a sexy reach for the familiar brass rail that ran along the back wall, stretching the length of the stage. The music kicked in and she offered her ass to the patrons. She was the one for me. I knew it. She turned and looked my way, seeing me attentive and appreciative. At the end of the first dance, I clapped too loudly for the room.

During the next song, she played coy and slid down the pole, looking like a tired housewife at the end of a bad day. She crept cat-like toward me, holding my gaze as if she was asking me a question. I wanted to give her the right answer. The music was thundering Led Zeppelin when tears filled my eyes. I saw my wife. The dancer rested her back on the

stage and writhed in pretend sexual ecstasy. I wanted the dance to be over, wanted to follow her into a dark room so we could fake being in love, but the song lasted forever and I knew there were going to be more, before she would head straight to the washroom, I imagined. I assumed she washed her hands a hundred times a day. With every song, she removed more clothing. Naked, bored, needing money, her faraway eyes grazed mine. The air was toxic.

When the dancer finally left the stage, she smiled at me. It seemed genuine, but I knew, in fact, it wasn't. I was the only man in the room clapping, and that would bring her to my table, I was sure of it. I prayed that she didn't stay too long in the washroom. I had a half hour before I had to pick up the heroin. Then I would have to drive like hell to the farm, and my wife would finally get her deliverance from the anxiety and pain, her bridge from suffering to paradise.

Then a hand brushed my shoulder and I felt an electric charge, and I turned to face the dancer. Her warm hand lingered, and then she tucked it inside my shirt. "I can make you feel good," she said. I nodded and followed her to a semiprivate room in the back.

In the dark, she sat me down and carefully laid her white towel across my lap. She sat down and lightly played with one ear lobe, then tugged. With the next song, the meter was running.

※ ※ ※

I'd driven the road to the farm a thousand times; its secrets were long ago revealed. I knew where the cops would be and knew all the coffee stops, the towns. I spoke the words I would never say aloud, "She's dying." I held the thought close in the car. A chill froze my eyes open, and I felt ashamed as I relived the past couple of hours. I wished I hadn't gone to the club. I wished I was a better man.

I could see the light of the farmhouse and couldn't wait to see her. I ran inside, and the relief in Carole's eyes made me feel worthy of my wife, made me forget my lapse, my regret. She'd been having a hard night. I efficiently laid out the heroin and chopped two lines with a maxed-out credit card, twin sisters on a blue plate. I turned on the charm of a cooking show host and presented them to her with the wit and class of a French chef. Carole was nervous, ambivalent, and filled with doubt. I reassured her the Buddha had given the medicine five stars, knowing I had to close the deal before she had any more second thoughts.

I rolled a fifty-dollar bill, guided and supported her frail body as she leaned over the plate and inhaled. We waited quietly. I then asked her how she felt. "Wonderful," she said. "It's warm." She lifted her hand to my face. I did something then that I had always been afraid of doing: I looked directly into her grey-green eyes. I'd never felt more love coming my way.

I brought tea. We were going to play Scrabble, like we used to. There was a bit of energy in the room once more. I

gathered the game board, then accidently spilled all the letters onto the floor and wondered if it was a bad sign, wondered why the letters spilled at precisely that moment. As I said, I saw everything as a sign of something.

I sat on the side of the bed holding her hand and with the other spelled the first word, five across, IRONY.

She carefully spelled the word EPITAPH.

"That's an unfortunate word," I said.

"It's worth a lot of points," she responded, "but I'm too tired to count them."

"We don't have to play."

"As long as I can quit anytime, I don't mind playing," she answered. "By the way, I threw out Rogers's picture tonight."

"Why throw out his picture tonight?" I asked.

"Do you remember when he came to Stratford?" she said, as if that was an answer.

"Yes."

"I was having an affair. My second to his four. He came to the bar where he knew I was going to be, grabbed between my legs, and asked, 'Is his come in there?' He choked me that night. It was shameful."

"Was that the night you broke his rib?" I asked.

She shook her head at the memory.

Clarke had been wretched because Carole was sleeping with a member of the Stratford chorus and felt publicly shamed, especially because the actor was so low in the hierarchy. That made it all so much worse for Clarke,

and at the time, it was up to his Hamlet to make him feel better, but Hamlet was already seeing his girlfriend in secret. He couldn't comfort his friend, so instead Clarke drove to Stratford at midnight and found her in the bar and humiliated her. Remembering this old guilt required something from me in the present. "I miss Clarke. I miss the dynamic of the threesome we were. When your love for Clarke shifted to me and we ended up alone, it was as if I was missing a key piece of something. The situation came with new responsibilities. I was asked to play myself and fill in for Clarke, too. And part of my role was to make you feel better about how bad it felt being with him."

With Scrabble now forgotten, I paced around the room, remembering my late friend with both pleasure and envy, and how there was nothing like being the subject of his words when he wanted to elevate you. No one could touch him in this regard, and I wondered if Carole loved me as much as she had Clarke. I had a vision of my old friend sitting before an early computer, a second-hand, huge, and clownish space-age tin box, an invader inside the mess of a theatre office. The computer's impact was felt right away as Clarke wrote grant applications, ceaselessly smoking while staring into the small screen. It was the eye of the future looking back at him. The typewriter wasn't his medium, but the computer became an instant friend.

"He never wanted me to be more than a critic," Carole said. "That was his role for me. He couldn't bear for me to be an artist. He saw that as his domain."

"He hated critics," I replied. "He called them parasites, said they were bloodsuckers." I felt mean and small-minded, mocking my dead friend.

"You do a good impression of him," Carole said, barely caring about the conversation anymore.

I watched her feel a good wave and roll of the heroin.

"I was his supporter," she said. "I liked his work. He defined a time and place. By the way, as a director, you like longueurs too much. You have to watch that in the future. Clarke never used them. He understood that every moment of theatre needs to interrogate the audience. He never let up."

I then wished Clarke was with us, the three of us once more around the table, Carole and I with our Bloody Caesars, Clarke with his Molson. Clarke could have explained the cancer away. He was smarter than anyone. He also had heart, and he was at his best around human suffering. People came to him when they were in real trouble. "Rogers was suffering's best friend," I said.

"He will never know his beautiful daughters," Carole said sadly. "Their mother the greatest Canadian painter since Tom Thomson, maybe better. Rae did some extraordinary painting when she first met Clarke. No one knew what to do with the colour blue better than Rae. She put blue on the map. Rogers was good at feeding the brain and confidence of people he loved. That should be enough for anyone. But he blamed me for the bad review *Hamlet* got from the *Globe*, thought you were being punished because

of me. Because the critic wanted me so desperately, the critic was going to destroy the theatre."

She looked at the window as if Clarke might be hiding outside. I also felt a presence.

I'd once lamented the damage I'd imagined critics had wrought in my life, all the doors of possibility that had been closed by unfair critics. My wife's sister, a therapist, said to me once, intending to comfort me, "Being a critic is inherently a self-destructive act. It's an act of killing the vulnerability in the self while humiliating others. It's a form of sadism, but every abuser was themselves abused. The title of critic provides the cover."

I'd never felt that was true about Carole. She elevated every conversation, but I had to admit that when you were the object of her anger, it was a little like being done in by a sushi chef. Carole had ceased being a critic and had found the journey to being an artist a complicated one. She'd spoken at that time about moving her inner furniture around, that changing the lens was painful. She had to look inside rather than out.

We both saw the curtain move. I felt a presence in the room and knew she did as well. "Are you cold if I leave the window open?" I asked. She laid her hand on mine and held it, "I feel fine now. I feel wonderful."

I wanted to let go of her hand. I didn't want her to sense my growing fear. I wanted to protect her from my feelings, but she knew I was uncomfortable inside my own skin. She knew all my tricks.

"Who gave you this miraculous powder?" she asked to break the tension.

I flattered her like Clarke would have. "The man who gave us this heaven on earth loves your books." I was performing for Clarke again, knowing he was there with us.

Carole sighed. "Thank him for me."

I wished I was high with her and remembered doing the same drug with Clarke at a very similar farm.

I went to the window where I knew Clarke's presence was dwelling and pulled aside the curtain, peered out, half expecting to see my old friend in the darkness.

"Remember how he ate?" Carole asked. "A slice of toast with an egg and two small glasses of beer, around noon."

Her low caressing voice, a surprise from such a vulnerable woman, made me understand how much I was going to miss her. I wondered how I would be able to live without her when she said things like she did then. "You disappeared into his narratives for you."

She touched her tumour as if forgiving a baby.

"He compared himself to the Viet Cong," Carole said, "throwing their bodies across the razor wire, on the way to defeating the enemy. A self-image you cannot be saved from. Rae was a strong woman, but Clarke broke everyone. That was his gift. He broke you so he could be the only one to put you together again. If you loved Clarke, he had to break you. He could not abide anyone loving him."

For the first time, I recognized an obvious truth. "He gave me a chance to play a prince, on and off the stage." I

wished I'd been a better friend to Rae after the loss of Clarke four years earlier, but my guilt had shut me down. I never knew how to include another person in what had been the triangle of Clarke, Carole, and myself. I was the one who mopped up after Clarke at the theatre, and I dropped the mop after I ran away with Carole.

The room became quiet, and the other enveloping presence disappeared. Clarke had come and gone.

Carole let her hands flop on the covers, exhaled a long breath of knowledge and sadness, and, as if abandoning her own body, said, "I miss parts of him."

She laid back then and asked for music, a chanteuse from Portugal, fado music—there is none sadder—and asked me to repeat songs. She was heading into a universe of what I prayed was light.

* * *

We walked down the gravel road framed by grass fields and wheat. Stepping off the road, we went through the grass; a light breeze eased the intensity of the sun. She wore a hat that made her look like a member of the royal family out for a stroll. She'd dropped the juice diet, and she ate and drank almost nothing then, only small amounts of apple sauce and soup stock.

She moved carefully, each step an act of courage. We would talk about our daughter at first, as we always did. I told her of a party on the weekend, Charlotte had slept over; when I'd picked her up, I was impressed to learn that

not one teenager had driven home after drinking. There were sleeping bodies piled everywhere.

Carole asked if Charlotte liked any boy. I said I suspected that something was going on. "Good," Carole said. "She's so goddamn horny." We both laughed.

As we walked on, the smell of the grass reminded me of my prairie childhood, intimations of sage, alfalfa, and other sweetness I couldn't identify. She asked, "What do you think happens after you die?" I wished then I could carry her in my pocket, safe. She appeared small for the first time since I'd known her. We'd discussed death only once before, long ago. At that time, I had attempted to be both practical and philosophical. "We're here now, and that's what counts," I'd said. "We're all going to die. Let's focus on the healing."

But now something more was being asked. I looked into the blue sky for answers, for faith, for wisdom. Nothing came. I didn't know anything about dying. I couldn't be sure of anything. She was the best read and most knowledgeable human I'd known; she'd absorbed Western and Eastern thought. None of this helped her now. She was looking to me for answers, her hand resting on my shoulder as we moved through the waving grass. I didn't know what to say, and my heart was breaking. "Dying is a beautiful part of living," I finally said. "It's like birth in reverse. When we die, we are born into a new light, that's all I know."

She smiled, and in her touch, I felt all of her.

After walking on a while, we stopped, the silence only broken by the sound of insects, birds, far-off cows and dogs;

there was the faint drone of a tractor in the distance. In this moment, our marriage was fulfilled. Anyone watching might have only seen a couple standing in a field, but this was a moment into which everything was distilled, pristine—the frustrations of living, unfulfilled giving, hopes that never materialized, surprises of joy, loyalty, secrets—all of it was simultaneously permanent and transitory, informing what we felt then. I looked at my love, with her lost curly hair, her eyes steady and grey-green, and knew our being together was right. It was enough for me. We turned and walked back toward the farmhouse.

* * *

Fall 2000. After the sympathy, the festival of sorrow, and all the kind words, my daughter stayed the first few nights at her aunt's. I was alone in the house where death had visited. I was a widower.

I went to the fridge, opened and closed it. I reached for the garbage bags under the sink, not needing one. I turned music on and off. I flossed, brushed my teeth, looked at my face in the mirror, and realized that all of life's small tasks were absurd. I clicked on the television and wanted to throw it through the window when a commercial popped up. Clearly, the world was not stopping to grieve with me. I was bone-drained empty, back to the emptiness I had felt before I met my critic and novelist wife; an old dry ache was taking hold once again, and I was alone like never before. I found myself romanticizing my life with her and

not one teenager had driven home after drinking. There were sleeping bodies piled everywhere.

Carole asked if Charlotte liked any boy. I said I suspected that something was going on. "Good," Carole said. "She's so goddamn horny." We both laughed.

As we walked on, the smell of the grass reminded me of my prairie childhood, intimations of sage, alfalfa, and other sweetness I couldn't identify. She asked, "What do you think happens after you die?" I wished then I could carry her in my pocket, safe. She appeared small for the first time since I'd known her. We'd discussed death only once before, long ago. At that time, I had attempted to be both practical and philosophical. "We're here now, and that's what counts," I'd said. "We're all going to die. Let's focus on the healing."

But now something more was being asked. I looked into the blue sky for answers, for faith, for wisdom. Nothing came. I didn't know anything about dying. I couldn't be sure of anything. She was the best read and most knowledgeable human I'd known; she'd absorbed Western and Eastern thought. None of this helped her now. She was looking to me for answers, her hand resting on my shoulder as we moved through the waving grass. I didn't know what to say, and my heart was breaking. "Dying is a beautiful part of living," I finally said. "It's like birth in reverse. When we die, we are born into a new light, that's all I know."

She smiled, and in her touch, I felt all of her.

After walking on a while, we stopped, the silence only broken by the sound of insects, birds, far-off cows and dogs;

there was the faint drone of a tractor in the distance. In this moment, our marriage was fulfilled. Anyone watching might have only seen a couple standing in a field, but this was a moment into which everything was distilled, pristine—the frustrations of living, unfulfilled giving, hopes that never materialized, surprises of joy, loyalty, secrets—all of it was simultaneously permanent and transitory, informing what we felt then. I looked at my love, with her lost curly hair, her eyes steady and grey-green, and knew our being together was right. It was enough for me. We turned and walked back toward the farmhouse.

* * *

Fall 2000. After the sympathy, the festival of sorrow, and all the kind words, my daughter stayed the first few nights at her aunt's. I was alone in the house where death had visited. I was a widower.

I went to the fridge, opened and closed it. I reached for the garbage bags under the sink, not needing one. I turned music on and off. I flossed, brushed my teeth, looked at my face in the mirror, and realized that all of life's small tasks were absurd. I clicked on the television and wanted to throw it through the window when a commercial popped up. Clearly, the world was not stopping to grieve with me. I was bone-drained empty, back to the emptiness I had felt before I met my critic and novelist wife; an old dry ache was taking hold once again, and I was alone like never before. I found myself romanticizing my life with her and

diminishing my life before her. I gazed at the empty space where Carole's final resting place had been, and I knew I would be out of step for a long time, perhaps forever.

It had been six years of living with cancer.

I was rocked by a tsunami that followed an earthquake that was a ten on the Richter scale. This was real life after real death—the unthinkable and unimaginable had happened. My emotions came in huge rolls, and I nearly blacked out. I lost control, rolled on the floor, and howled. When the sobbing finally ebbed, I lay on the polished hardwood thanking God that Charlotte had not witnessed my grief, and then I realized I needed to focus on my daughter. I didn't care about myself anymore, but her passage through the coming months would be crucial. She had given a bravura performance at the funeral, but inside there was an unbelieving child unable to face the horror of what had just happened.

THE UNDERTOW

Mexico was the smell of corn tortillas, and I made it my mission every day to buy them fresh for Charlotte who stayed awake late into the cool nights and slept through the blazing morning sun. Friends had given us their Mexican house for a couple of weeks to help us heal during the first Canadian winter of our loss. The house rested on the cliffs of the Pacific coast near one of the world's great surfing beaches, and it wasn't far from the square where I bought my daily stack of tortillas, wrapped in insulated foil, warm and inexpensive. When I got back to the house, Charlotte would spread peanut butter on them and eat them with teenage delight.

One day, on my way back with the tortillas tucked under an arm, I stopped at a store and found myself flirting with a bottle of amber rum. I hadn't had a drink since my wife attended a writers' retreat in Banff when Charlotte was

four. She was fifteen now, and it seemed to me a shame to break an eleven-year streak. Still, after losing my wife, who could blame me? I thought. When Carole was alive, whenever I thought about drinking, it was something I couldn't see myself doing again—the fear that my drinking would chase my wife away kept me sober. But I no longer had that worry, and I told myself it would be okay to begin anew my affair with the bottle. Surely, my dead wife would forgive me.

With little fanfare, I bought the bottle. The clerk had no idea what was at stake; it was just another transaction with a tourist wearing a straw cowboy hat. As I walked the few blocks back to the house under the searing sun, I simultaneously had the feeling that I understood everything and nothing, and then I chose not to ponder the matter further. I was a little bored in the evenings and the rum might help, I thought. Besides, I hadn't been on a holiday for a long time. "A couple of drinks," I said out loud to myself. "The world doesn't have to end."

Back at the house, I hid the rum in my room upstairs. I didn't want to spook Charlotte. She didn't need to know. I remembered that when I would buy my wife wine or Scotch, Charlotte would say, "You're drinking through Mommy," and I would laugh at the half truth of it. My drinking was only a story to her. But now it would take on new weight. Before she lost her mother, she had said worriedly, "What scares me the most is Mommy will die and you'll start drinking again." I promised that would never happen.

That night, in the bedroom, I opened the bottle and mixed myself a drink, a rum and orange juice, just to see how it sat. It was the taste of Jamaica, but I felt a numbness of spirit. I had been writing a series of prayers, to whom I did not know, but I did know that Charlotte and the fountain pen were all I could believe in then. But I was forgetting something important—how and why I had managed to give up drinking, and why I had never had any slip-ups since. It began when I spent four days sober while Carole had been away in Banff. I'd simply and suddenly had enough of the feeling of being drunk. I'd had trouble one night finding my car when I was with Charlotte, and though I hadn't been particularly drunk, I felt terrible about my little girl worrying that her dad didn't know where he'd left his vehicle.

I took a sip of rum, picked up the pen, and remembered how things had been when my wife got home from the writers' retreat. Something was up. She had danced in the kitchen, she'd lost weight, and I knew the signs. She had fallen for someone. I unfolded a blank page and, wanting to see myself from inside her experience, tried writing in my late wife's voice, but it felt false, off. I couldn't write like her, but I wanted to imagine how she saw me. I had searched through her writing after she died, looked for myself in her words. I wasn't there. I was absent. Why was that? I wondered. My self-esteem rested upon the rock of our marriage, and this rock had turned to sand when I found the letters she had begun to her lover. I needed to go to the centre of the hurt. Or was it fear? I'd experienced

terror in my life, the time I'd nearly drowned on Fire Island, a place off Great South Bay with a ferocious undertow.

I'd been in New York as a young actor studying, and my famous acting coach had taken me along with her other students to Fire Island to say goodbye at the end of the summer. I'd gone for a swim and went too far out alone. My fellow students were waving at me worried, calling me in as the sun was setting at their backs. The rolling backwater had trapped me, and I couldn't manage the overpowering waves. I might have given up and drowned, except my fierce performative pride saved me: I did not want to go down in the eyes of my classmates.

I felt the same fear when I found my wife's letters. She and her lover had been planning how they would meet up and that she would leave me. I felt like I was being swallowed by something huge, never to be found again.

In the Mexican heat, rum and pen in hand, I realized I had not yet fully felt the impact of my wife's death. I knew the absence of her and imagined that, perhaps, I could fill the empty space with her voice. I would invite her soul into mine. I would become her, writing in that small Toronto kitchen dominated by the washer and dryer. I was an actor; I knew how to lose myself in another entity. It would be like painting; she had used watercolours to free her imagination. She would roll white parchment paper across the floor, drop to her knees as if in prayer, and sweep out her feelings with colour, her emotions running from heart to brain through the hand. These mood furies were then taped to the wall,

and I would discover myself haunted by them. I would feel as if I was shrinking, becoming nothing, that all I had was my secret life, a life that had her at the centre. I knew that she did not want that, that she did not want to be the only thing inside me that mattered. And I *had* finally lost her. That was certain. But why did I want confirmation of her love after her death? It troubled me. What was the purpose?

I began writing: "My husband feared me leaving him more than he feared my death." I crushed the paper in my fist, tossed it at the bottle of rum, and missed. I took a drink. There I was judging myself off the top. Typical. The key, I thought, was to find the grace she found in writing. I had to begin with something true, something simple. I started again, remembering something she had said.

> Hold my hand, let me get a better look at you. You have lovely eyes, let me describe them. No? Okay, I won't embarrass you. They say you can tell from the forehead whether one is Catholic or Protestant. They're very different. Protestants feel oppressed by the language of fundamentalism. That's not what it's like for a Catholic, whose primary relationship is with the image, not the word. You smell the priest's breath when he leans over to give communion; he dresses in dark robes and has power to grant or prevent salvation. You confess to a priest, not to Jesus Christ; it's a medieval ritual. French Catholic is even better. French is a wonderful language for love, and for describing

atrocities. A martyr's death is exquisite when rendered in my native tongue.

My love adores ice cream for the taste and the guilt it brings. I asked him why. He said it was the only form of sin Protestants embrace. On nights when I was reading, he had a way of digging into a cardboard container. I'd hear his footsteps, then the freezer door opening and rat-like noises as his spoon scraped like a shovel in the bin. He'd creep around in the half dark, swooning from the pleasure. He enjoyed the regrets more than the ice cream. He would confess his pleasure as if he'd visited a brothel. He might have been happier as a Catholic.

I stopped writing. You need to write about where the hurt lives, I told myself. Be honest.

I was in the kitchen alone after the Banff incident writing my poet a letter. I'd arranged to phone my lover from a telephone booth safely located in a parking lot. I'd missed that appointment, because earlier in the day my husband had found evidence of my affair. I'd hidden a letter in my glasses case and then forgotten where I put it. My husband was uncanny at finding things. Truly useful in some situations, but a liability under these circumstances. My nerves were raw from a day of unbearable confrontation. To calm myself, I poured a glass of wine and dropped it. The

glass exploded. I put the shards of glass in the garbage can. I was afraid the noise of the breaking wineglass had woken my husband, and so I shredded a new letter into tiny pieces before depositing them with the remains of the glass. I knew I was being watched, all my writing examined in secret by my husband. Sure enough, in the dead of night, he went down to the kitchen, thrust his hand into the garbage to retrieve my writing, and cut his fingers on the broken glass. He sat through the night bleeding and Scotch-taping the tiny fragments of paper into a coherent whole, blood smearing the parts he most wanted to read and reread. He showed remarkable patience in doing this. He was not a man who did puzzles at Christmas. He did not like board games or anything painstaking. But this was the exception. He could go to any length if it involved humiliating himself. I was just collateral damage. The person he was building a case against was himself.

I let my poet go; I let the feelings die, careful to protect and nurture my husband's dignity. How hard it is to not pursue the images that torment when one attempts to rebuild the entire structure of a marriage. Painstaking work and harder than Scotch-taping a broken document of love. Trust is required, though it is not in abundance in the home after a spouse, a love, has strayed.

A few months later, I repaid in kind: I read his journals. I suspected some form of revenge was brewing

in him, and I couldn't resist rummaging about in his words. My husband had been spending more and more time writing in a café close to our house. He'd told me a story about hugging an actress on Bloor Street. After embracing her, he felt doves flying from his chest. She had released a flock of birds that had been resident there. Something was going on, but I was mistaken with whom. He had a crush on a waitress down the street. He wrote long, passionate passages about her ass. You would have thought it was Notre Dame. The ass was a shrine he visited when the sun fell, a call to prayer. He is one of the unfortunate ones, sexualized too early. He looks at a horse and sees a woman's ass. I took to my bed, alarmed. I had fallen for the idea that he had eyes only for me; he'd made a fuss about that for so long. Then the waitress quit the café, which helped.

For him, it was the Protestant fire from above. He was running from the fire. I was running to the fire. My Catholicism demanded me to burn, as Joan of Arc burned, surrounded by men calling my name.

Never enough time: the damage is done in a few vulnerable years, and we spend an eternity sorting it out. During his darkest period, he took to calling his conscience a bitch, for it tormented him. I thought he was speaking about me and that he'd been listening to too much hip-hop. I feared he'd adopted the gangster ethos, not the best role model for a father.

But no, when he spoke the word *bitch*, he meant his conscience. His conscience was the shrill woman who would not let him be. He experienced her lash, and he would strike back at her with this damning word. "You bitch," he'd say. My husband internalized a God who was angry. He desired God to be a woman, confused the voice of the inner critic with his conscience.

He and I became the portal through which our daughter had to pass. We were together to birth a spirit. I loved him, desired and required his attention, and yet I strayed outside the marriage bed. My sister defends me, says that some relationships create affairs. Perhaps it's their only purpose. Sometimes we follow our hearts, no matter how dangerous or wicked. Children are put at risk, and yes, children must come first. We are redeemed through our children and our work. But sometimes one simply needs to follow their destiny. This is one of the hidden rules of marriage. Routine affects the social unit. I could say I had my affair for my daughter. I was a happier mother after that, a more loving wife. These are complex matters, our fates having been written in our hearts, not our minds. Our bodies are home to our hearts.

We patched it together. He had excess energy from not drinking. But he was a lapsed black sheep. I remained his saviour. I knew it. I encouraged it. I regret that.

With more time, I would have finished my last novel. It was going to be my international bestseller, my Humvee. I was driving it through the heart of England. I had relented and wrote about sex and art as if my very life depended on it; wrote about a love triangle in the nineteenth century, a story of two artists. One, a painter with a good sense of business, and the other a man who thought he was the business side of the equation when in fact he was the better artist. Two artists, and a woman who served as their model and muse; artists desire to worship the women they paint. The model wishes to believe the artist painting her is a genius. At that time, for a woman, it was the best one could hope for—that a man's gaze was more than an objectifying tool of control.

We are driven by our core experiences as a child, must fight the world for our space, make self-definition a virtue. We can't bribe our conscience. My husband and I were creatures who loved our secrets. We needed double lives, for different reasons. A religious faith says you are sinner, with the church holding your soul as a mutual fund holds your money. The rules are there in black and white, easy to follow, like footprints marking steps on a dance floor. And we follow, each in our necessary way.

I adore actors and appreciate what their art can do. Writing was my theatre. I costumed my ideas and sent them out into the world as my children. This was my

husband's bridge to my heart. He truly was an actor. He lived fully only when he was on the stage. The audiences' eyes relieved his dreadful Protestant shame and sense of duty. The guilt that was encrusted on him like zebra mussels had no power over him in the theatre. The theatre was a glorious liberating storm that swept into his heart and let him love unconditionally. Well, it's impossible for a family to compete with that.

My writing was an unfolding secret. My husband's acting was his joy, and all his secrets were manifest in the theatre.

Sexual longing drives everything forward, causes all of the trouble and most of the pleasure. And sexual desire cannot be constrained by monogamy, no matter how much we wish it.

After I died, I watched, every morning, as he would drop our daughter at the alternative high school on College Street. She was between old and new Toronto. She took an elevator up to class, and at the end of the day, she'd walk alone through the business district to the theatre her father ran. These were the streets Glenn Gould had haunted. The lake everyone forgets to the south.

I witnessed him removing her clothes from her knapsack after she returned from Quebec City, where she had gone to protest with all the students from her school. It was early in his single parenthood. Her clothes had the stink of the tear gas the police had fired

at them. She modelled the second-hand army-surplus gas mask she'd purchased midway through the protest for him. She made him laugh walking the runway from the living room to the kitchen. He washed the gas out of her clothes, deeply proud of her.

My writing hand ached in a way that made me feel good, and I put the pen down. I felt satisfied, as if I'd spent some unexpected time with my wife, and I had found it easier being honest about my feelings and myself while channelling her. I remembered what she had said about "drunk writing," that it "migrates between rage and sentimentality." I took one more sip of my drink and realized I hadn't heard anything from my daughter in a while. She would be hungry. I decided I would cook her a good dinner, and then I poured myself another rum and orange juice.

The day before, the two of us had taken a taxi to the beach, and she'd gone swimming alone, getting caught in the undertow. The powerful current held her down so she couldn't breathe, and she struggled and cried, her tears mingling with the burning salt of the Pacific. I knew the water was dangerous, and I kept careful watch, sensing she needed the experience to give her strength. She was desolate without her mother. All that my wife had wanted for Charlotte seemed impossible now. Carole had been so careful to ensure that her daughter would grow up with every part of her fed, that there would be no longing, ache, or emptiness in her core.

I had a last drink, splashing a drop of rum on the writing paper. I unconsciously penned over the rum stain with something Carole once said, "There is no catastrophe equal to losing a parent when you are young."

I rushed to rescue my daughter from the undertow. She needed a father.

HAPPY NEW YEAR

The traffic was bad, and my heart felt like an ash pit. I couldn't tell if I was having a heart attack or if I was just terribly unhappy. The sun was just above the car, and I found myself saying out loud, "It's unseasonably warm." I was alone in the car. "How much more can I take?" I said. "Where's the bottom?" Everybody's bottom is different, I thought. I didn't say that out loud, thinking I needed to control the talking-out-loud stuff as it had gotten excessive over the past several months. I decided I'd work on that in the new year.

I thought about the second lap dancer, not the one I'd seen while waiting for the dealer, but the one I'd seen when Carole was in the hospital, near the end, about sixteen months or so earlier. Jesse was her name. She'd worn a pleated skirt, a real Bible school fantasy that one. I had

chosen her immediately over the other beautiful women in the room. I couldn't remember the music that played at all, just the excitement of being close to a naked stranger.

I could see right away that she knew I was married. She asked me right off. I admitted it. I apologized in fact. She said, "I don't mind, that's how I make my living. Most of the men who come in here are married."

Then she disarmed me. She pulled my ear lobe and smiled, just like Sharon had, just like the first dancer had, and just like my first teacher had done in grade one when she told me I was a good speller. I could feel myself falling in love with the dancer the way I had with that teacher. I wanted her to see I was not like the others, that I respected and admired her, that I respected the way she made her money. I did.

She told me she was from Romania and that she would wait for the start of the next song, that way I'd get full value. Her hands and arms dangled loosely around my neck and shoulders, and we sat like old friends while the song played out. The smell in the room was of overwhelming longing and unfulfilled desire; that, and the very real smell of perfume. My wife would be able to notice the perfume right away; she was allergic to it. She'd feel nauseous even if someone in the next room wore it. It didn't take much for her, just a minimum of exposure, and this place was a radiation dump. It would register high on Carole's Geiger counter. However, that was a problem for later. I just wanted to drink in the feeling of having this

beautiful creature sit on my lap. She asked if I had been working. I said no, that I'd been at the hospital. I told her my wife was sick.

A new song began, and Jesse put her mouth up to my face and she whispered, "Can I just sit like this for a while? I don't feel like dancing right now. Do you mind?"

"Hell no," I said.

She put her cheek gently against my chest.

"I like this," she said in a quiet voice. "Do you?"

"Yes, very much," I said, wondering if the metre was on.

She asked me which other girls I liked in the room. I said they were all nice but that I liked her the most.

"Thank you," she said, "but I'm not the most beautiful. Don't you like the Asians? I think they're exquisite."

"Yes, I like them very much."

"Have you been here before?"

"No," I lied. I wanted her to feel special.

She told me she'd worked there for four years and wanted to quit, but the money was too good—then the song came to an end.

"Would you like some more?" she asked.

"Yes, please," I said, and I paid another twenty dollars.

She took her top off.

Her breasts looked real, but I didn't know for sure, and I imagined a bouncer punching me in the face if I touched them. Anyway, I wasn't obsessed with breasts. They were lovely and I was coming to appreciate them more, but the question I had was, What do you do with them?

Jesse never took off her skirt—she seemed to know the power it had over me—and I wondered if she wore those pleated numbers on the street. You'd watch the women at the club arriving for their shifts looking absolutely normal, like anyone coming to work, but their little bags were stuffed full of the sexy stuff. If one outfit didn't get any bites, they'd change into another. Different customers called for different strategies, different looks.

My god, Jesse is kind, I thought. She told me a story about one of the girls and I laughed at the punchline, but then I remembered my wife in the hospital and felt like a bastard for laughing.

Jesse noticed. "Are you thinking about her?"

I nodded.

"Is she nice?"

"Yes, she's wonderful."

"Is she going to get better?"

"I don't think so."

"That makes me sad."

"Me, too."

"Do you have anybody to talk with about that?"

"Just you," I said, believing that sometimes women were messengers from my childhood, the one ruled by a punishing God.

After I left the club, I realized that I'd left my hat behind, my favourite hat. I'd picked it up for Carole at the Gap, but she never wore it, so I did. I loved that hat. But after the lap dance, I'd felt pathetic and only wanted to escape, so I

couldn't go back for it. Later, I imagined running into Jesse somewhere while she was wearing it.

When I got back to the hospital, Jesse was still burned into my skin, so I rubbed fresh green leaves over it to disguise the smell of the perfume and walked down the long hallway, excited to see Carole, my real love. I had realized there was something about hospitals that excited me. The fear and grief aroused sexual longing, as if they were hot-wired onto the same circuit, as if a pleated skirt was an antidote for grief. Was being with Jesse cheating on my wife? I wondered. It was intimate, loving, and restorative, at least for the short term, but why did I really go to the club? Was it a way of having the atmosphere of love and sexuality without any of the responsibility? When we had been in Mexico several months earlier, Carole had offered me a guilt-free association with a sex worker if I wanted, had smiled wanly and said that conventional morality did not interest her much at the time. She said I should take care of whatever I needed. I assured her that sex was the last thing on my mind, which wasn't true. I was hungry for everything bad. I wanted to escape to a brothel of delights. I wanted alcohol, the excitement of strange women. The desire rose in me like yeasty bread.

My fragile wife asked me to rub her back, but I pressed too hard and she asked me to stop. I felt like crying but refused to. I needed to embody my inner John Wayne. I looked out the window to the parking lot where I'd had to pay to leave the car and said, "Twenty dollars. What a rip-off."

❋ ❋ ❋

I checked the rear-view mirror and wondered how many other widowers were on the highway. How many others were suffering a midlife crisis, were just another burned-out building in Berlin? The empty space in my chest where my heart had once beat was suffocating me from the inside. It was hard to breathe or drive. I tried to forget about my chest, wanted desperately to be happy. I had a trunk full of expensive booze to gift and was hoping someone would offer me a drink when I arrived for the new year's dinner.

As I looked for the turn-off to Hamilton, I asked myself why I liked pleated skirts so much, and I made a mental note to ask my new and much younger girlfriend if she had one. That morning, she had shoved a burning spear into my chest. She wasn't getting enough out of our relationship and was on the verge of leaving me. She'd reminded me of Carole's affair, suggested there could have been more lovers I didn't know about. As the spear pierced, it hit some part of me still alive and I felt a delicious pain, felt love then anguish, a motherlode of jealousy. My girlfriend was working the deepest vein in the mine.

Bursting into sobs of hurt, I took the exit to Brant Street and decided I would tell my girlfriend about Jesse and the pleated skirt, that I'd cheated, too. I didn't want my girlfriend to dislike my wife. This was very important to me. I needed my girlfriend to love my wife as much as I had.

My girlfriend had given me an important lesson that morning; she taught me to look deeper into why people act the way they do. She said my cleverness and ability to read people's motives were tricking me into believing that what I thought I knew was the only deal in town. She said you have to look behind all of that. Asked what my particular behaviour was hiding. She had a good point.

I was ashamed of myself, no question about it. At first, the younger woman thing didn't bother me. I felt grateful for the attention, and she had recognized my broken heart because she had been abandoned by her father. It was best not to follow that one down; I was old enough to be her father. In fact, I was a year older than him. I liked her friends, but I didn't get their social references, and I hadn't seen any of the television shows they talked about. I found the way around the awkwardness was to always sound like a professor, and I told myself my experience and knowledge would benefit my girlfriend in the long run. I tried to tell myself that I was kind of like a degree she was earning.

I waited for the threat of her leaving me to wake some panic and remind me of my charred and decaying humanity, but there was no panic. Only cars like mine driving through the unseasonable sunshine.

I knew there wasn't much waiting for me out there. Knew I was never going to have children again, didn't want to. I wanted to be a grandfather someday. I thought my Charlotte was really all I should be paying attention to, but she had her own separate life. I knew my humanity rested

on the last thin plank that connected me to her. She was seen as mature for her years, but of course that was just a performance, and although she was most convincing in the role, I still saw her as nine years old, the age she'd been when she learned of her mother's cancer.

I was getting close to my sister's house, and I was counting on thinking about something else when I got there, was confident I'd be protected from my thoughts by my own performance—as the younger brother and uncle who was doing well after the tragic loss of his gifted wife those sixteen or so months earlier.

"Unseasonably warm," I kept repeating aloud, as I drove down the main street of Hamilton. It was early in the day, and the sun was as bright as on an August morning, though it was New Year's Day. "What's on the resolution list?" I continued, talking to myself as I parked the car in the driveway. "Christ, it's a long list."

Make your girlfriend happy.

Try to at least like yourself.

Walk, don't drive.

The drink is obvious, so why mention it?

Quit whining.

What else needs quitting?

Talking out loud to yourself.

There's more.

Oh yeah, find joy in the daily tasks of life.

Understand loss as a major part of the human equation.

Loss and hope equals life.

I'd been drinking too deeply of the loss. It had been feeding the chaos and the death wish, and I wondered where the hope had been hiding. Perhaps I mistook the girlfriend for hope? I may have been shopping for meaning and found myself clinging to a younger woman. And what about the pleated skirt? Was that hope replacement therapy? Or was it shame? Shame equalled pleasure, but it was also a handmaiden to the death wish. Shame equalled suicide.

I couldn't think about this, or anything, anymore. I believed in world peace, believed nonviolence was better than violence. That Nazis deserve to die—that was true—but who were the Nazis? What lay behind them? The pleated skirt was hope; fuck the Nazis. I opened the trunk of the car by flicking the leaver under my car seat. I loved the sound of that pop. It was a kind of reliable hope. Then I asked myself, If my girlfriend is hope, why am I so angry at her? Am I angry at hope? Despite my girlfriend saying she might leave me, she was also afraid of losing me. Yes, a contradiction, but she hadn't twigged the fact that when a man is missing to himself, he's probably not going to be found by anyone else.

As I reached into the trunk, I craved a lap dance, like I used to crave ice cream. Everything had been simple for me then. My world was sick, and I was losing what defined me. Feeling bad was easy; working at feeling better was hard.

I pulled two bottles of champagne and a bottle of tequila out of the trunk, and blinded by the light of the January-like-August morning, I hurried to the house.

As I reached for the doorbell, I asked myself what lay behind the lack of happy love. Ding dong. My chest hurt, and I thought about what it meant to feel the warmth of August in January, and if it mattered how I felt if the world was going to end anyway. In the Hammer, hope was a cold day in January.

The door opened and there stood my second oldest sister. She looked more and more like our mother, whom I didn't think about very much anymore. I thought about my wife instead; she had become like a mother, a spiritual mother in a halo of light. My girlfriend called that putting someone on a pedestal, and I remembered my wife saying you have to look at why people do that, said that putting someone on a pedestal hides some greater painful truth being denied. I thought about the pain in my chest—which wasn't really pain, more like a loss of hope—and realized I feared the demands of hope. As a child, I heard over and over, "Don't get your hopes up."

"Hi there, where's the baby?" I asked. My sister laughed and hugged me in that stiff way that my family dealt with touching, but I was warmed by the affection I felt for her. I remembered her coming home to the farm when I was a child and chasing me for what seemed like an eternity, because she wanted to give me a kiss. She'd just returned from Bible school, and I recalled the fear in my heart as I ran away from her. She caught me and trapped and held me between her legs, held me in the folds of her Bible school skirt, a pleated skirt—is that where that came from?—and

sat me on the porch steps of the farmhouse. She hugged me and wouldn't let me run away. She held me tight, laughing, kissing me on the side of my face. She was so pretty, and it was the first time I could remember ever being kissed. I was four years old and didn't remember anyone ever hugging me before. I remembered a photograph that was taken that day, remembered the shame I felt as a boy, the shame about feeling pleasure, the shame about holding onto the people you love. Why had my mother never kissed me?

Then my sister said, "The baby's asleep, but don't worry, he'll be up soon. He's still on BC time."

"I want to see that baby," I said.

I closed the front door as my sister hurried away to pour me a coffee, but what I really craved was alcohol. I wanted to be back in the car thinking about a lap dancer. But that was a bridge back to what? Back to hope? No. Back to my wife? No. Back to my girlfriend? Back to betrayal? No and no. Back to shame? Back to what the fuck?

What lay behind the shame? I asked myself. Hadn't I answered that already? I was confused and more emotional than I'd been in a while. My sister handed me a black coffee in a black mug. I struggled to remember what I'd been thinking about. My girlfriend had really hurt me that morning, or was it yesterday morning? My sister slapped me on the back. I hadn't eaten anything all day, the house smelled like turkey, and most of the guests hadn't yet arrived. My BC relatives were in the basement.

The girlfriend will leave.

Okay, say it: Drink has to go.

Coffee equals hope.

You should eat something, I thought, as I opened the fridge door. What if I had a beer now? Would my sister find that weird? But the coffee tasted fine. "This should work," I said aloud.

"How's Charlotte?" my sister asked.

"My daughter equals hope."

My sister smiled and laughed. "She sure does."

"What did I do with that list?" I said, surprised I'd said that out loud.

"What list?"

"My list of resolutions."

"Oh, you will always be reminded," my sister informed me. "There's no need for a list. We never forget the stuff we want to forget."

From the basement door off the kitchen my relatives poured in like a familiar burble rising from an underground river. There had been pain and disappointment in the family in recent years, for the dearly departed, over divorces and losses, but there was also hope with the newly arrived, the weddings, and the comings together. I heard the baby in the basement, my cue to become the uncle bearing gifts.

The first of my relatives to come through the basement door was a man I'd always loved, my brother-in-law's brother, an older figure in my life who made me feel like I was interesting, who shared my doubts about Christianity, who beat me every year at Crokinole. In fifty years, I'd never

won a single game. The Crokinole King slapped me on the back and said, "Look what the cat dragged in. You're looking good. You must be a regular at the gym. How are the reps? Last year you scared us a little—you were looking very pale, but you've got your colour back and you've lost some weight. Happy New Year. I hope you're ready for a great day in the Hammer."

EIGHTEEN

Charlotte and I had gone through an unexpected time. She'd had her mouth wired shut to straighten an errant tooth and couldn't speak for a month. It had brought us closer. She communicated through sign language, mime, and written notes. For me, it was like living with a silent-era film star. Eventually, I joined her in writing notes back and forth. The stage when father and daughter would yell and stamp their feet was replaced with exchanges of short, pithy, and sometimes witty writing. We discussed some raw and delicate points, finding it was often easier to read the truth than to hear it spoken.

One day, I went out to rent a movie and didn't return for four hours. Charlotte was enraged and had been afraid of what had happened to me. I feigned indignation, as if I had no liberty anymore, and then the usual poses arrived one after another. My daughter wrote on the edge of a newspaper, "You can't hide from me. I feel everything you feel."

Our house was a staging ground for self-punishment. It appeared to me that sometimes Charlotte was starving herself, and that she was in late-teen rebellion against her curly hair. I once waited for her at the house of a close friend who had a straightening iron, and when she came to the door, I was shocked by her beauty. Through my eyes, she lived within a kind of halo. It had been a rough couple of years, and I desperately wanted her to heal, but I also knew she was resilient. I'd given her a strong back, and her mother had bequeathed both beauty and brains. It was comforting to think like this on her birthday, to accentuate the positive.

Charlotte's eighteenth birthday party was at an old friend's house with a mix of people. Friends of my late wife were there, my daughter's peers, and more than a few twenty-something artists, my favourite demographic. Everyone had been asked to write about or speak to their own memories of turning eighteen. It had been a particularly busy day at the theatre—we had a semi-hit show and that was about as good as it got those days—but at lunch I'd flicked on my computer and crunched out a few lines of what I was going to call poetry. Turning eighteen was a special occasion, so I did my best to whip up a froth of enthusiasm. My daughter was dreading her party, but she was also ready to put on a good show.

We entered the house to cheers and the popping of ice-cold champagne bottles. I hadn't eaten all day, because I was suffering from the anxiety of throwing the party—I'd produced shows with less fear—so the champagne raised

my consciousness into a bubbly frisson of yellow brick roads and rainbow sunrises.

We sat in a circle in the front room, and each person at the party read their memory. An actor that I'd admired for some time read her actual journal entry from her eighteenth birthday. It was revealing and funny, and the party took on the tone of performance art. Memories generated instant revelations, and several themes emerged: isolation, fear of the future, denial of aching loneliness, obsession with appearance, overwhelming need, surprising sophistication, and longing for romantic love.

I was last in the circle and stood to read my poem. I couldn't rhyme, and I knew nothing of poetry. I felt it was one thing to fail in front of your friends, but it was another to have your daughter witness it. I hadn't had time to reread what I'd written, and I remembered Carole telling me that if you failed to prepare, prepare to fail. I suddenly felt like I was a naked, no-talent father; I'd failed to smother my fears in champagne. All I had going for me was my sincerity; I loved my girl. The lines were short, and the rhythm had to be invented. I wasn't auditioning, though: I already had the job of father.

Eighteen

When you were born
two weeks late
in a March storm

I held you all red
in my stiff frightened hands
I'd tried to be nice
to you in the womb
I fed your mother chocolates
gave her back rubs every night
I was hoping for someone
like you, a girl.
I thought I might
be able to teach
a girl what I knew
I was ready to give
what I had taken
and then you winked
at me from the
swaddling clothes
and I saw a face
that I'd looked
for all my life
all round and knowing
you seemed older than me and wiser
in control of events
and you wouldn't let me teach
you anything
you saw through my
tricks and called
me on lies.
I knew

children are
sent to teach us
not
to be us.

Thanks for the eighteen years
at the university of Charlotte.
I remember eighteen,
I was starting to get over
the brainwashing.
I was innocent and scared.
I was angry at a world
dedicated to money.
I was ready to throw myself at the feet
of women and fight
the system.
I was halfway to
the most important
event of my life,
helping bring you
into the world.

After your birth
my mother mailed a quilted baby blanket,
fresh from Saskatchewan.
A message for me
on one side,
it read,

Love me,
on the other side,
I love back.
I tried to do that
that was my strategic plan,
that's it.
Love me
I love back.
Eighteen years ago
I needed healing
and you gave it to me.
I'm grateful
it was you,
born in that storm,
both of us born
in that March storm.

And
even though I
hurt my back
and spent the
next ten years
on my knees
picking up toxic
plastic toys and
obeying your
commandments
and whenever

> you did something
> you asked me to
> "Talk about it."
> You dragged me out into the open.
> You gave birth to me.
> You loved me,
> I loved back.

When I finished, I thought the poem had gone over pretty well. My daughter held on to me, and for a moment we lived in a world that needed no fixing. We had what we had. We were what we were.

Charlotte then addressed the room. She looked each guest in the eye and thanked them individually and with enormous empathy and imagination. Charlotte had made connection a religion, and by the end everyone was glowing.

I went alone into the backyard. It was March 3, and this year, like every year, had produced a snowstorm. I snuck a cigarette bummed from someone at the party. The moon wore a golden haze for there was magic in the tobacco and it induced a trance. How proud Carole would be of our daughter, I thought.

I left the party and walked through Parkdale. Charlotte was sleeping over. I was alone in a part of town that I was beginning to like more. Something about Parkdale matched my experience of loss. I stumbled up Brock past the liquor and beer store, becoming more sober with every step. It was going to be uphill all the way home. I liked

the railway bridge and the urban decay; the rescued decay signalled rebirth to me more than all the new stuff built over the years. I realized it had taken me some time to feel proud of my adopted city. When I had first arrived, many decades earlier, it was not cool to like Toronto. You had to cultivate a sneer to live here, but perhaps that had changed. If only my wife were alive, I could have asked her. She had said in a speakeasy on Queen Street before we had gotten together, "Young Toronto does not recognize that by cultivating a sneer, they are mocking their own dreams. They are mocking the very notion of even having dreams."

North of St. Clair, I sat in my empty house and stared at the pictures on the walls. The light in the bedroom revealed dust mites that looked like fairy dust falling. I found myself asking, Who lived there? I had to remember; not remembering wasn't working. I thought that maybe it was time to abandon the house for good, as well as the bad habit of seeing everything as a sign. What if there were no signs? Sometimes it seemed to me that my vanity was as durable as a cockroach in a nuclear winter; I loved my pain because it was all that was left of Carole.

I wondered if there was some kind of way I could turn my pain inside out. That maybe there could be another side to this coat I was wearing. It could be simple, I thought. I could make my daughter the centre of my life. She had said she would go either to New York to study acting, or to Montreal to study to be a playwright. I hoped it would be Montreal, but the National Theatre School there only

accepted two writers a year. I felt that she would get a lot of attention in Montreal; in New York, you'd have to buy the attention. I also wanted her to have a different life than an actor's. I knew that writing was in her genes. It was written in her bones.

EAT AMBITION

She was doing it again. I'd been at the theatre when Charlotte called. She called my Toronto office phone, which she never did. It made the call seem distant, but more alarming. I was in a business frame of mind before the backdraft from hell sucked me out of it. The unknown did come with many knowns: acid reflux tastes and smells, the sound of a toilet flushing, again and again, and the fear that gripped me when my daughter would disappear into a bathroom and stay far too long. I knew she wasn't doing her makeup. She was in a fight for her life with the cobra, the dual-headed snake of body image and her mother calling from the dark pit that dwelled in the guts where the loss lived. I booked the train to Montreal. It took an hour less than driving.

Charlotte had had phases of eating only certain things. I wouldn't call them food. She had the pickle stage, the

gummy bears, the corn puffs, the raisins, and the spiced almonds. I could smell them all in my heart. I could see the encrusted cups and bowls and the insides of cardboard containers placed under her bed, stuffed with corn puff effluent, on ledges and shelves in hard-to-reach places, hidden under clothing, balanced on a laptop, everywhere. I had followed the trails and read the signs. Yes, she was perilously thin, but everyone liked her that way. She fielded a steady stream of compliments. I knew the day of reckoning was nigh. Yes, we did all of the things we were supposed to do. Everyone knew the list. Therapy, check. Better communication, check. A healthy, structured plan, check.

The anxiety was in my feet as I jerked my way to the sliding door of the Via Rail car's washroom. In the strange metallic universe that smelled of government-issued cleansers, I looked into the mirror, into my own eyes, and asked if there was a father in there who might help a daughter needing something more than pep talks and shopworn encouragements. I remembered the Thai soup I'd buy in plastic containers, burning my hands as I carried them to the car and then home. The life-giving, century-old recipes would soon be flushed into Lake Ontario. I felt the tepid swamp of the poisoned lake and the growing algae of dread and fear.

I wanted to pass a fierce and wild belief onto my daughter: that in the end, things work out. But exhibit A, her mother's cancer and death, was hard evidence to refute. I had to give Charlotte that one. That was not an example

of a silver lining. But I did want her to believe that, generally, after the hard knocks, softer, gentler beauty arrives, or would arrive, if patient. The cheques in the mail and summers in Newfoundland, a new love, a movie deal, a successful show with box office appeal and acclaim—even though these things might come irregularly, there was still the promise of good news. That was life's low-hanging fruit.

In an attempt to convince myself that optimism was not a fool's hideout, I considered the merry occasion when I'd won an arts award and it came with a cheque, money that had bought a new laptop for my daughter. The laptop had led to a happy ending itself when Charlotte won a playwriting prize at a young age and then eventually gained acceptance into the National Theatre School of Canada in Montreal. I felt it wasn't unrealistic to hope that the school would become an ark that would help carry us through the present storm. She'd fought a good fight, but the beast had risen again. Daddy was on his way; speed the train.

She led me to a tea house on Rue Saint-Denis as I had promised myself no drinking until she was better. I'd lived my life with a Saturday night–Sunday morning tension, and that day was definitely a Sunday in our souls. Tea had a church-like feeling. Out of the frigid air and after our shoes were stacked on a shelf, we faced each other in sock feet. Her socks did not match; there was a small hole in one of mine.

In first year, all the students at the theatre school had to write and perform a ten-minute play. It was this that had

brought on the crisis. She had had an abstract idea based on a cartoon character—Betty Boop, who would be eating a green apple—and I remembered she'd asked me once when she was younger, "Daddy, what is it about women and apples?" I explained as best I could the story of Eve in the Garden of Eden, that women found apples irresistible, that perhaps it was the seeds in the core, the heart-like shape, the crisp taste, sweet but not sugary. I couldn't see myself helping much with the apple play, but then she had another vague idea.

She might do a piece about food and an eating disorder. The audience would be given a small plastic bag containing a dill pickle, representing grief; a corn puff, standing for ambition; and a raisin for love, or an erotic ideal. The gummy bear was goodness. I lost track of why.

She said she could perform a monologue with a story from her life tied to her feelings specific to each food group. The audience would bite into a pickle and experience the taste of her grief. She'd existed on a pure pickle diet for weeks after her mother died, eating them like you might gulp fish swimming in a jar before washing them down with the vinegar brine. I tried to imagine the sound of two hundred audience members biting a dill pickle as they remembered someone they'd lost. I had come to believe we spent too much of our time thinking about her mother, so I changed the subject. "Corn puffs are ambition?"

The memory of congealing corn puffs was not easy for me to forget. She had exhausted the corn puff stage

over a year as an auditioning actor after the alternative high school. She went Hollywood, wore outrageous and provocative outfits, and zealously committed to a corn puff diet. It was a virulent and effective kind of crack cocaine. She was up against blondes who wore dress sizes no larger than zero.

Ambition for a teenage girl in Toronto-Hollywood meant auditioning for a season of rape victims. She told me that because she had dark and naturally curly hair, she was a perfect rape victim on American television. "Blondes are not sexually assaulted on American television," she said matter-of-factly. I burned my tongue on the scalding tea, struggling with my reaction, then said as calmly as I could, "I didn't know that, but it makes sense."

Her hands were cold and she warmed them on her cup. She told me about auditioning for rape victim parts that season. "I found myself in rooms with groups of white men gathered around tables." Here, she tightened her body and performed for her father as she had at the audition. In a trembling vulnerable voice, she said, "I feel dirty. I'm ashamed. I don't feel clean anymore." At this point the men would say—and she imitated their questionable sincerity—"Thank you. That was really beautiful. Thank you for that."

Her last role was as the victim of a terrorist's missile punching a hole in a passenger jet. She played a teenage girl being ripped from her mother's arms and sucked out of the plane, her curly shoulder-length hair flailing in the wind,

providing visual impact as she rocketed to earth below. Evidently, blondes were also not victims of terrorist attacks.

Charlotte did her own stunts, which paid three thousand dollars more for the terrorist victim role. I was impressed. This was pure Hollywood North, a movie-of-the-week-in-Toronto experience, and some anonymous power figure in Los Angeles had personally commanded Charlotte over the telephone, "Take not the Lord's name in vain as you hurtle to certain death." Under no circumstances was she to add a line like, "Oh God." The Americans couldn't handle that. The other concern was the colour of her lipstick. "Nothing too red."

I brought us back to the play. "I remember the corn puffs."

"Yes, they're ambition," she said, as she held up her hand with an imaginary corn puff held between finger and thumb. "Eat ambition."

Despite her humour, she admitted she was having trouble swallowing and that she'd had a particularly bad week. I didn't want to spook her, but I noticed her fingers were the colour of pale carrots. She was anxious about the performance in a week and wondered if the show really had to go on. I was keeping a close watch on what I said.

It was then I realized what my role was. It wasn't to advise on the script; she was more than capable of writing on her own—she was already better than me at telling a story. I was there to comfort her. She needed me not to judge her or question her idea, but to love her and listen and witness her struggle. I loved her idea and I loved her

and felt, despite my concern for her health, an unexpected pleasure to be invited into her process of art and healing. We spent three days of togetherness and blissful contemplation fashioning the script. There was a painting of her mother resting on the top of a bookshelf in her sparsely furnished apartment, and I fixed my eyes on my late wife's face while my daughter read drafts. Her words took me down the river of the last few years.

The play was funny, and it rescued me from fear. Her truth lived inside her solo clown, which she had fashioned out of the culture of our family, her panic and pain, while she recounted twenty years in ten minutes. I felt my own heart beating inside her short play. This was the girl that love gave me, the one who came to teach me. This was the daughter of the woman I was born to love. My return to Toronto on my last morning in Montreal scared both of us, and we clung to each other on the icy porch. Then I got into a waiting taxi.

At the train station, I poked the remnants of an industrial sandwich, remembering my last words to her before I left. "I will not drink, if you do not purge."

Although we'd spent a week sharing that promise, I guessed she might fall soon; I already had, as evidenced by the half-empty beer beside my sandwich. But I did not feel despair. I believed my daughter's talent would keep her safe and be her redemption. I remembered her last words as we'd said goodbye on the porch. "Addiction is so boring, Daddy."

AN ANCIENT PLAGUE

I leafed through a copy of *National Geographic* I had found on the couch beneath my daughter's plane ticket to Ghana. On the front cover of the magazine was a close-up photo of a mosquito, the night predator, 1,500,000 years old. The bloodsucker who outlived the dinosaurs. Inside the magazine was a story about malaria, an ancient plague returned. I tried not to fuse that information with the fact that in two days Charlotte would be leaving to spend the summer in Ghana before her final year at the National Theatre School. I was tuning my innermost ear to what Charlotte's mother might have said regarding this travel plan, but she was sadly silent on the matter.

The following morning, Charlotte forwarded a let's-calm-the-father letter from the young Edmonton man taking her to Ghana, a playwright at the school, a special fellow evidently. He'd been going to a Liberian refugee camp in Ghana

for several years and contributing money to a family as well as a dance group that had formed there, and he had dreams of founding a theatre exchange program with the people in the camp. The young man had been to Ghana three times and said reassuringly that malaria wasn't an issue where they would be staying. He knew the country and said Charlotte would be well cared for and never in any kind of danger. At night, they would be staying in a clean and safe hotel, far from predatory insects. In preparation for the trip, father and daughter found the right shop, and the right clerk, and settled on cream-coloured outfits that would hide and protect her skin, as well as strike a neutral class note.

At the airport, Charlotte forbade me from coming inside with her. "Say goodbye at the car and drive away," she told me, saying she would email when she could. Her cellphone wasn't making the trip.

The next morning, I bought a newspaper and checked the headlines. There was nothing about a Canadian girl in Ghana, but I couldn't help but dwell in the past where all the bad news was filed.

One week after my daughter left, Charlotte phoned me with a calling card. She told me that despite the conditions in the camp and the poverty she saw, she found herself in awe of the raw human power of love she was witnessing. She was making new friends and learning. I said little and listened, knowing my role and that my daughter was okay. As time for the call ran out, Charlotte said reassuringly, "I miss you. I love you. Don't worry about me." Then the

phone call was over, and I floated down the street looking for someone with whom to share the good news. But while the visible tip of my iceberg was celebratory, the mass beneath the waterline was pure anxiety. My girl was the one thing that kept me hanging on.

One week later, I received another call. "Hi, Daddy, I have malaria. I'm in a hotel and being looked after by two wonderful young men. I caught it at the beach. But I'm okay. I've got the drugs. And I've been to a doctor. I'm coping. Please don't worry too much. Daddy, are you there?"

"Yes, I'm here, honey," I said as calmly as I could, trying my best not to sound alarmed.

"I can't talk more right now," she told me. "Someone is getting me a new phone card. I'm in bed resting. I feel a little bad; the drugs are very strong. But I can feel myself getting better. Are you okay?"

"Yes, I'm fine," I lied. "I'm just thinking about you."

"It's so nice to hear your voice. I miss you. I always miss my daddy when I'm sick."

"Yes, I miss you, too. What should I be doing?"

"Nothing, Daddy. I'll be home in two weeks, and I'm going to be fine."

My gut told me this was not going anywhere good, and in the middle of the night I got another call. She was having trouble breathing, said it might be the drugs. I suggested she fly home on the first available flight; she thought that was a good idea. It turned out the hospital she had gone to wasn't really a hospital; it was a kind of makeshift clinic.

In her voice, I heard something new and dreadful: a shortness of breath. Charlotte's breathing sounded constricted. She said that everyone around her was telling her to just relax, that things would be fine, but she didn't know if that was true.

After the call, I gave myself a good talking-to. Ever since she was a toddler, Charlotte had not been one to cry wolf. If she said something was rotten in the state of Denmark, it had to be true, and one would do well to listen. I knew she had to be brought home, and soon. I could hear her mother's voice calling me an idiot for letting her go, that I should have known that young people can be reckless and make decisions that bring unforeseen disaster. Where was the missing adult in this? He was on his way to the bank.

I made an extra-large payment on my Visa. The airline said there wasn't much they could do; Charlotte was too far away from an airport. I would have to arrange to get her to Accra and then book the flight. There was no point in making the booking until she was ready to get on a plane, I was told. There was also some possible trouble of her boarding a flight when sick. I'd need clearance from the health desk at the airline.

On our next call, Charlotte said the drugs were not working. I used my best father voice, the one I couldn't remember ever using: "Get to the Accra airport."

I waited for the next call. When it came, I was told there was a brave taxi driver who could take her to Accra,

a four-hour drive through many roadblocks. Charlotte was running a high fever, but she was still making sense.

I was worried; it was coming down to the wire. There were no seats available on flights for perhaps nine days, and the airline's health desk was still demanding a letter from a doctor before allowing Charlotte to fly. There was zero possibility she'd be allowed to fly without one. Charlotte was calling every few minutes from the back of the cab with horrifying commentary.

During the night, she had thought she was going to die. Her mother had visited her and had said mysteriously, "You have to survive—the world needs you to write two things." That was it, but Charlotte had smelled her mother's breath and had remembered her own birth. As the call ended, as both a father and a writer, I wished my late wife had been more specific. How was Charlotte supposed to know what two damn things she was supposed to write? I worked the phone and got a woman from Air Canada on the line who said she'd book a seat as soon as I could guarantee my daughter was near the airport.

Charlotte's next call was more alarming. She could barely speak, and she had to focus on her breathing as some pressure was making it difficult. She and the young man from Edmonton were on their way to the Catholic hospital in Accra, but the trip would be expensive, I was told. I got the young man on the phone and shouted, "Do anything, pay anything, get to the goddamn hospital, and get her home!"

When Charlotte got to Accra, I asked the airline to book the seat, but I was told there was nothing available, that all the seats were sold, that it might be four more days before anything opened up.

I was desperate and pleaded, played the father card. My years of acting training were not required for me to convey the emotions I was feeling. The woman from Air Canada said she'd see what she could do. She phoned me back and said she could get Charlotte on a flight out the next day, but it would have to be a first-class seat. I took it.

Charlotte called from the hospital. A United Nations doctor had seen her, said she had been on counterfeit drugs, but that she was going to be okay. She was hooked up to an intravenous drip as she was dehydrated; she was given morphine; she was finally on the right drugs. She was relaxing and could breathe. She said they were slaughtering chickens outside her window, but that the hospital was clean. I listened to her story as it stopped and started, and she told me her Edmonton friend would get her to the airport at six o'clock the next morning.

There were many power blackouts throughout the night; the hospital security guard wanted her email address but was nice about it; and a nurse brought her a pineapple from the street, which Charlotte felt terrible for having to refuse. She then had to figure out how to be discharged. A UN doctor who had just returned from the Congo said he would help her, and he emphasized that he wanted her in the health care system in Canada.

Charlotte was happy enough on the morphine, knowing the worst had passed.

I spent the next two hours on the phone with the health desk in Montreal. They were unmoved. They needed the doctor's letter or my daughter couldn't fly. There were no possible exceptions to the rules. Charlotte couldn't get on the plane without them receiving the release form from the hospital. I wasn't sure of the time difference between Toronto and Accra, but I had a feeling that if I kept the health desk on the line Charlotte would board the plane with or without the form. On the other line, my daughter told me that she had arrived at the airport. She would try to get on the flight. She had a bit of minor bad news, however. She had an accident at the hotel. She went from the hospital to the hotel to get her stuff and wanted a shower to get five days' worth of grunge off her body. But the fever was clinging to her skin, so as she stepped into the shower, she fainted, slamming into the toilet basin as she fell, pulling the shower curtain from the wall. She may have broken a rib, she said. Well, maybe two. I hoped the champagne in first class would help her with that. She'd see me at the Toronto airport, she said, adding, "I love you, I can't wait to be in my daddy's arms."

I had the Montreal health desk on hold while I was still speaking with my daughter. "Hi, thank you for waiting," I said, after switching back to the call. "We're faxing you the form letter as I speak. Have you got it yet? No. Well, it's on its way. My daughter's flight is taking off soon. I understand.

Everything is done. You'll have the letter in seconds." I kept it going like this for half an hour, at which point the public health nurse conceded that Charlotte might be able to fly to Frankfurt without the form letter, but in Frankfurt there would be no possible continuation of the flight unless they had an actual release from a doctor. I played along. By then, I was confident Charlotte was well into the air. I paced up and down the street in the August heat; my precious cargo was coming home.

* * *

Twelve hours later, I was at the arrival gate, heart in throat. Charlotte exited the automatic doors looking boney and pale, but at least she was walking and smiling. I held her for a long time, and neither of us said much. For some reason the tropical disease clinic in Toronto was closed for the week, so we spent the next couple of days visiting clinics and emergency rooms. As it turned out, in addition to malaria, Charlotte did have two broken ribs.

During the day, I made my daughter vegetarian soups and peeled her fresh fruit. At night, she cried and talked when she slept, which was rarely, and she had horrifying dreams. Recovery was slow. I confessed that I'd found the copy of the *National Geographic* warning about the resurgence of malaria and that it had given me pause regarding her trip. She laughed and told me she'd read it weeks before leaving on her trip, and she had hoped I hadn't seen it, knowing I'd be worried. For the next few weeks, I stayed

close at hand, like when she had been a child, my baby. My grief for her mother was put aside.

The medicine she was taking had severe side effects, and I helped her get through the worst of it by entertaining her with tales of my misspent youth, and by reading to her from a pulp biography about John Kordic, the NHL enforcer who'd come to a tragic end at the age of twenty-seven. It was a story of how a cold and unfeeling father, unreachable emotionally, who offered his son nothing but criticism, had sentenced a gifted young man to a life of addiction and violence.

Charlotte had grown up believing that I loved her mother more than I loved her, but during this time, she began to see it differently. She thanked me, said that she was a father's daughter, and that she saw the world as a girl raised by a man.

A few months later, I watched two new plays being performed that Charlotte had written based on John Kordic's story. The plays explored relationships with fathers and how children are formed in ways that they are not able to see while growing up. The plays were seen by the hockey press, who were astonished that a young woman could understand boys and men so well and could write so authentically about a game so beloved and dominated by men.

When Charlotte was well enough, I drove her to Montreal to begin her final school year. I realized I was going to miss her more than ever before. As I left, I took

the long way through the city, my wife's former home. Montreal was the one Canadian city that was possible to love as you would a mother, or even a father.

OPENING NIGHT

I was driving to the Factory Theatre, heading south on Bathurst, a street with no grand buildings and few trees. If there was an off-Broadway district in Toronto, this was where you would find it. It's remarkable in any city to have theatres offering new plays, but Toronto has many situated on or near Bathurst. Where it crossed Bloor was Honest Ed's, the long-time landmark discount store, where many an actor starting out went to furnish their apartments, or where one could find solace when facing a faltering relationship or otherwise unexpected move.

Bathurst is my street of memories; my final drive with my wife was from the south end going north. We were heading for the hospital, and we both knew where the drive would end. The last ride up Bathurst Street after spending the summer in the country near Lake Huron made her reflections all the more acute. She said she was sorry she'd

come to Toronto all those years ago, that the English never appreciated her. She thought she could have done better in New York, that they would have appreciated her gifts more in America. She believed Americans did not resent the French the way English Canadians did; they lacked the WASP prejudice toward the arts. It was the last thing she had to say about her writing. It hurt her when she was not included on the fifty best writers in Toronto lists. She felt she'd given a lot to the culture of the city, and it did not seem to matter.

I reminded her of the day we'd gone to Front Street at dawn to buy a *Globe and Mail* from the newspaper box that had a review of her first novel, *Voice-Over*. We had walked twenty-three blocks down Bathurst to get it, had laid the paper out and read the review together, and returned home swimming in the feeling that her book had been understood. Carole danced, touched her hands to her heart, and cried silent tears. The man reviewing the book buoyed its birth into the world, making Carole happier than I'd ever seen her. I did not say it out loud, but I knew how important she was to the community. No one could replace her. Her reputation was much bigger than she realized.

I was stuck in traffic thinking about critics, about how I bore a grudge against the critic who would be in attendance at the theatre that night. Once I'd amused myself with the idea of waiting in the shade of a tree with a broom to clobber critics for bashing shows that I couldn't even remember by name anymore. Some critics were a problem

for all the theatres in the city and seemed to relish mocking people and making them feel small.

This one critic, who'd dogged me for what seemed a life sentence, however, had presented a full-page profile on Charlotte, her new upcoming play, and had spoken of her mother's legacy. The story was a good one, and it helped publicize the show before opening night. It told the story of a seventeen-year-old writing about her celebrated mother's death, that it was a farce about loss from the point of view of a child. The girl had a long-lasting case of lice infestation, which was the play's prevailing metaphor for two years of grief. You could scratch and scratch and never get any relief. In the critic's feature, the play was billed as an autobiography. Yes, there were true things in it, but it was a work of the imagination. A comedy can rarely be the documentation of real life.

The critic who had haunted me wrote an appealing and glamorous portrait of Charlotte, but as a theatre worker who had long suffered this man, I knew this was part of his marinating process. That often when a critic lathered on the praise, the grill soon followed the false hours of celebrity they lent their subjects. They seemed to know that the more they built you up, the further they could knock you down, and perhaps self-servingly, they knew that the papers often preferred negativity over positivity when it came to the arts.

Historically in Toronto, arts critics acted as if they were the police enforcing British traditions. In their opinions,

Canadian theatre was to faithfully serve these customs. In Saskatoon, the 25th Street Theatre was heavily influenced by the work of Paul Thompson and focused on local and regional culture, developing work that was by and relevant to Canadians. I carried this dedication to Canadian subject matter with me when I came to Toronto, and for a decade as the director of a theatre there, I was convinced the company had been unfairly singled out as a symbol of Canadian aspirations. It appeared to me that critics treated the theatre as if it were an English boarding school and that my company was continually in need of a good six of the birch. There was an annual ritual of presenting a full plate of plays per season and then having your dreams publicly extinguished by those dedicated to colonial traditions and not particularly open to the storytelling forms of other cultures. Being punished for wanting to be originally Canadian was undeniable.

* * *

The Factory Theatre is near the bottom of Bathurst Street, and on the opening night of Charlotte's play, you could feel the lake over the horizon. It was fall, the sweetest time in Toronto, when the nights are warm and when twilight is the colour of honey. On this night, there was a grace note—the theatre had spruced up the neighbourhood of boarded-up industrial buildings by placing a splash of colour on its fence, and for the first time in memory, I saw a large billboard advertising a young writer's play. The

summer dust clung to the poster of hair and fingernails, my daughter's real hair, curly and wild, the colour redder than her natural hue, and the fingernails elongated to emphasize the play's title, *Scratch*. The hair was the home for the lice, and the fingernails were for the scratching. In that poster, I saw my daughter's clown and knew that, no matter the outcome or response to the show, I was going to be laughing. As far as critics were concerned, Charlotte was from a different time, so I hoped her battles would not be the ones my generation had fought. But she was starring in her own story, and that made everything more fragile. As her father, I had to live with the distinct possibility that I might see myself rendered, and not in an entirely pleasing way.

Charlotte had written the play before she had completed her National Theatre School training. I'd trekked to Montreal a few times to see her plays at the school, and there'd been fathers in all of them, each portrait vivid. One father was an insane drunk who kept his bed by the front door and believed that Jesus had planted fish sticks in his freezer. This father couldn't seem to turn on a lamp without cursing. Another was an emotionally absent and abusive man in one of Charlotte's plays about famous hockey enforcer John Kordic, who tragically died after overdosing on cocaine and brawling with police in a Quebec hotel room. The dad I identified with the closest was the father of a stripper who would turn up the thermostat and sit in a hot living room with his daughter in their swimsuits, pretending they were in the Caribbean. Charlotte had a gift for

placing archetypes in outlandish situations. This meant the dads in her plays were more out of control than I considered myself to be, and it rubbed up against my vanity—a minor sore point, but they're always the ones that grow. But on this night, I brushed aside thoughts about what mattered to me more: a successful play, or a flattering portrait of myself.

As I stepped into the dappled light, I parked my fears with the car. There would be no hiding in the shadows. I would not be drinking that night; I wanted to be present in every way for my daughter. I felt like I was going into a boxing ring more than a theatre. I would be fighting images that might be representative of my own experience, and with that kind of exposure, I always felt nerves and terror. I knew a whole supportive community would be there—it takes a village to raise a daughter who can write a play—but I felt a little like a salesman, and that what I would be selling was the idea of a proud and happy father. Indeed, the first words I heard when approached were, "You must be a proud papa."

I snuck a cigarette with an older writer. I'd allow myself two that night. The writer, too, asked me if, as the father of the playwright, I had ever been more proud. I said I was very proud and then launched into a story. I had a habit when nervous of veering off into unwelcome anecdotes that were mildly awkward. "Around the time Charlotte wrote this play," I began, "she took an Amtrak train to New York to visit her boyfriend's family. Her boyfriend was already there, but by mistake had left his toiletry bag

behind, so Charlotte took it with her. This was post-9/11 and everything was crazy at the border crossings."

I paused, wondering if the story was appropriate to tell, but it was too late. I was already committed.

"The customs men entered the train and walked through the cars like they were looking for terrorists. They didn't check anyone until they got to Charlotte, which was worrying for her, especially since after the attack on the towers everything had been cranked up to hair trigger.

"Charlotte is not someone who cries fire in a theatre, but she remembered the toiletry bag at the top of her carry-on luggage and knew it could be a problem. She recalled her boyfriend admitting that he'd once smuggled dope across the border in this sort of bag—she's not a dope smoker, doesn't like the disconnection—so she wondered if there was a bag of weed in there. The thin-eyed custom man searched her main luggage. His alarms appeared to be going off, like he smelled a rat while poking his way through the carry-on. He grabbed the toiletry bag, like he knew these kinds of bags are often where drugs are kept. He took hold of the zipper."

At this point, I asked my writer friend for another cigarette. It looked like I was going to have my night's allotment before the show even began. The older writer smiled as he lit the smoke for me. I then wondered if I was becoming a bore, if maybe I was well past the *becoming* part.

"Charlotte stared down the beady-eyed man in the uniform. "Scuse me, sir, I'm sorry, sir, but I have to tell you

I'm having a really bad period. I'm bleeding like crazy, and I had to change my Tampax in the washroom. It was super bloody and I didn't want to put it in the garbage, leave it for someone on the train to find, so I put it in that bag. I feel terrible. I made a mistake, it's a young girl's bad judgment.'

"The customs man looked like he'd been shot and fell back. He stiff-armed the toiletry bag back to Charlotte like he could not wait to let go of it. She took the unopened bag from him and stared in shame at the floor. The air was charged with the horror of menstrual blood. The fellow motioned to the other officers and together they quickly marched off the train, leaving the other passengers wondering what had taken place. When the train pulled across the border, Charlotte opened the bag, and you guessed it…"

The older writer, either amused or in relief that the story had finally concluded, finished the sentence for me. "She sees the weed right there on top."

When she phoned me from the train station and told me the story, I thought that for a seventeen-year-old, she had showed mature insight into the male mind, knowing that sometimes when you are a woman around men, you have to think on your feet.

Story and cigarettes finished, we entered the theatre. I settled into the middle of the front row, my preferred seat. I like to be close to a performance as well as see it. I instantly regretted my choice: others could interpret it as a form of grandstanding. Oh dear, I thought, as I steadied myself for the fading of the lights. Then I looked around

and saw the beautiful friends who had cared for my wife at the end, who had bathed her in love. They were all in the front row with me, and I felt tears coming on. Seeing them calmed me, and I knew they felt the significance of the event. They knew why they were there. This evening, Carole's daughter would be crossing a bridge. Charlotte would be stepping into her own skin, her own reputation. The lights faded.

At the top of the play, I was afraid that someone would forget their lines or that a circuit would blow, plunging the stage into darkness. I was in a ferocious grip of anxiety, and a friend squeezed my arm several times. The show investigated a world of obsession, of losing someone so important a young girl retreated into compulsion to survive. She didn't ask for sympathy and balked at sentimentality. I knew this interpretation of a young person's tragedy, this forgoing of asking for victim status, would be the crux of the critic's scathing denunciations.

Then came the father. He had no spine and was servile toward the girl's mother, was cowering and over-comforting, and was inept in almost every way. But even so, the real-life father had to laugh. The man playing me was more handsome than I am, and I really couldn't ask for more than that, but then I felt ashamed to be having such petty thoughts.

As the play progressed, the young girl's sexuality mushroomed in the crucible of her loss, as if sex was a substitute for the lost mother. Shamelessly, the girl chased an older boy, determined not to let her mother's death interfere

with her awakening sexuality. All the while, the lice and grief wouldn't retreat, making the alarming behaviour more poignant. There was nothing shy about the presentation. The actress playing the role, my daughter, did not shrink from any blast of social disapproval. Charlotte rifled the puck straight into my heart until I could no longer stand the sorrow, and I had to keep reminding myself that the play would end soon enough.

The final note of the story was the moment when the father called his daughter with the tragic news that her mother had died. The fifteen-year-old was giving her first blow job to the older boy, who was a poet and charged with caring for the mother. This character didn't exist in real life, but there was a blow job and it did end at precisely the moment I'd called with the news. Charlotte told me the story after her mother's funeral. We found that sharing everything at that time helped. Her enduring memory of the moment was that the boy came just as the phone rang. She heard the worst news of her life while feeling the sticky mess in her wild and unruly hair. In the play, this scene made everything more shocking, and somehow I knew a bad review was coming. The critic would pounce at the opportunity for shaming. I felt it on the horizon as a farmer does a good rain, in the bones; bad reviews were the rheumatism of my world. There would be serious trouble.

As an actor, you could blame a director or the play itself after a bad performance, and a director could blame the

producer, but a playwright is on their own. Critics, and audiences for that matter, have a special category for playwrights: if they don't like a play, they pretty much hate the writer's soul. There's nothing quite as vulnerable as being a playwright, except maybe being a playwright acting in their own play.

At the end of the show, I hid in the men's room, in the single stall, and thought my late wife might be there with me. I mumbled to her that the actress playing the mother was very good, but that perhaps the father could have been a little stronger in his dealings with her. I imagined my wife's ghost saying, "That's true."

Talking in the men's toilet to a ghost, I made the point that, Charlotte has a way of finding a flaw and then expanding it and lingering on it, and this creates a kind of theatrical magic where the recipe tastes delicious to the audience, but the original owner of the flaw can't help but feel somewhat under-bargained. With that, the ghost of my wife disappeared. She was rushing to join the party.

At the party, I lost myself in the hugs and the things people say on opening nights. No one talked about the blow job, and everyone was warm and loving and found nice things to say about the production. They were amazed that a young person could write something so inventive. I found myself tired after the anxiety and fear that something would go wrong, but I'd wished for the best kind of evening for my daughter and it came. I only saw Charlotte a few times at the party, but she was experiencing what

many do when they get what they think they want: a sense of, "Is this all there is?" Charlotte would learn that the process *is* the event.

I left the party early and alone. I wanted my daughter to have the kind of night you don't necessarily like having in front of a father. I'd been in theatre long enough to know that opening nights are sacred and are also opportunities to jump the fence and play in the meadow.

At the bar where I'd first secretly flirted with and then openly wooed Carole, I ordered a white wine and threw it back, looking to stent the fear and cauterize old wounds. I no longer lived in Toronto and was sleeping in the house of a family friend when I was woken at six a.m. by a vibration on my cellphone. It was Charlotte, and I knew she would be crying, that she'd read the review. It was worse than I'd feared. We went for breakfast together, and I steeled myself and didn't have much to say. For me, the bad reviews of the past tended to gather around the ones that came in the present, so another bad review was something I could shrug off more easily. For Charlotte, this was the end of the world. I realized I wanted to carry the hope I thought my daughter deserved. She had a remarkable career ahead of her. She had her mother's writing gift and her father's strong back, and she had an extraordinary work ethic. Despite the reviewer and his marinating process before the inevitable grilling, I could sense the steel forming in Charlotte's spine. She wouldn't be fooled again.

She asked me, "Why would he try to destroy a young artist at the beginning of her career? Shouldn't he be encouraging? I can face honest, helpful criticism. I know I have a lot to learn, but I feel humiliated. How does that help me? I'll survive, but the joy is gone. Why is he so hateful? What did I ever do to him?"

Normally I'd want to crush any man who hurt Charlotte, but for some reason I felt something different. Though I took the sting personally, I knew that joining my daughter in the hurt and rage was not the way to comfort her. I leaned away from the battlefield strewn with the corpses of her hopes and said something her mother had said to me: "You made the music flow from dark to light. You showed us the comedy inside the tragedy. You made us welcome life, not shrink from it."

I fooled with my scrambled eggs playing for time, hoping something else profound might come. It didn't. I was no longer sure who my authentic self was, but I did know Charlotte could write. The theatre is a world of unrealistic hopes and often bitter disappointments, but I also knew it was where my daughter's voice belonged. I looked her straight in the eyes. She was running toward her story and not away from it, as I had from mine. Evangelicalism had taught me there was only one purpose in life: you must live knowing you will die, and certainly you'll be punished. The only story that mattered is being born again. But Charlotte knew that feelings mattered and that you had to be honest about them. Later, I remembered a story Charlotte

had written shortly after her mother died and realized she knew me better than I knew myself.

> Because of his lust for never wanting to be found out or really known, or seen—no one, no place, no person or thing would ever be able to absolve him. He didn't want to be completely seen by God, by his family, and later by his wife, who had now become his god, so in turn he could never be completely forgiven by them.

"There's no point in pretending it doesn't hurt when it does," I said. "There's no reason to go through life bitter and angry about critics as I have."

In a faraway voice, my daughter asked, "Did Mommy hurt people?"

I felt the ice, thin and cold, felt that it could crack at any moment. I told Charlotte that her mother approached all artistic work with a desire to understand what was being attempted, and that rather than critiquing what might have failed and prescribing fixes, she engaged with the ideas; she tried to look at things from different angles. She liked being led down paths different from her own. The artists reviewed by her were excited to see what in their work had sparked her imagination. They often felt like they learned something about their own work from her, and they didn't come away from the experience feeling deficient.

"What was it like when you married a critic? Would you marry a critic again?" Charlotte asked.

"Well, everybody becomes a critic in a marriage," I answered. "All spouses give you unpleasant reminders of how you're doing, and it's hard not to take some of that stuff personally."

"What did you think of the show?" Charlotte asked. "That's what I want to talk about."

"I was surprised."

"At what?"

"The father."

"What about him?"

"Was that supposed to be me?"

"Is this a good time to talk about this?"

"Kevin was great. Everyone was. I just thought the father seemed a bit like a wimp."

"You mean a pussy?"

"Okay, I mean a pussy."

"It's not you, Dad. It's a character in a young girl's mind."

"You know what, I loved it. A daughter is a mirror. I love all the fathers you've written. You write good fathers. You give good mirror. I am a pussy."

"Sometimes, Dad, you are."

"I know."

Charlotte changed the subject. She wanted to talk about the review. "It's always Saturday when the bad reviews come out. A total stranger walks up and slaps a humiliation pie right in your face."

"Well, in this case, the stranger is a former theatre artist," I told her. "And there's no bitter like theatre bitter. Once, I

saw him waiting for a play to begin and I saw his love for theatre and knew it was equally as valid as mine. We're all quick to judgment when viewing what is not our own."

Charlotte limply mimed stabbing motions with her fork. "I'm being shamed because men are afraid to discuss sex, are afraid to look through a young girl's eyes. Well, go to therapy. Don't treat people like crap and wank off to their pain. My mother died." It became a rant. "You slayer of dreams, you shame merchant...your adjectives suck...you're unkind, unhappy. A dick, a prick, a bastard. Critic!"

She daintily took a bite from the fork, like she was nibbling on her enemy's flesh. "I'm not serious, I'm just acting," she said.

"Believe me," I said, "I know the fine line between acting and real life."

Charlotte laughed a hearty stage laugh. It was time to leave the table.

MEMORIES OF ICE CREAM

I was now an old actor, and I had been having memories of my childhood. I had been thinking about when our family had moved to Caronport, Saskatchewan, after we had to leave the farm. My mother ran the post office there, and my father worked at the Bible school as a carpenter and steam engineer looking after the furnaces. In grade nine at the Bible school, in church, I was listening to the drone of an evangelist, a man from some sister college in Chicago, Illinois. The preacher had a young girl in his sights. "You're gonna get burned, girlie," he hammered and repeated. The girl who got this special consideration was Korean, and her heritage was often a target for attention that singled her out and caused her embarrassment.

The evangelist from Chicago believed he was Billy Sunday and stretched out his words, sounding like a siren. "Pluck out thine eye, if it offeeeennndds thee," he exhorted.

He had started in on the Korean girl, before sounding the general alarm about all the evil among us in the hall.

I was about fourteen and halfway up the boy's side of the church with a sweet view of Jean. She was one row behind me on the girls' side. I only needed to slightly turn my head to look directly into her beautiful dark eyes, eyes she mostly kept hidden by her long black hair. One time when I looked at her, my eyes lingered longer than ever, and she read me in a glance. She knew I was thinking about the acts Billy from Illinois was warning us about. When we were in class, I would sit behind her and place my leg under our desks near hers. She never acknowledged the small gap between us, but I could sense she knew how close we were to touching and she didn't pull away. The rule of the school was boys and girls needed to keep one Bible width away from touching each other, but I desperately wanted to be closer than a Bible to Miss Korea.

In the church hall, the preacher's blonde daughter was helping to spread Christian "love" from behind the pulpit. She sang a duet with her father, had a pretty voice, and tilted a smile while bringing sunshine into the room with her harmonies. When she looked at me, I felt a quick blast of warmth, but nothing amorous was intended. She wore a mask of adoration for her father as he scared the sex out of the room. Still, I looked heavenward into the eyes of the immaculate American blonde. She levelled a stern, concerned eye on me and then softened her look. Her eyes seemed to say, I want you to get saved so badly.

The congregation then rose and started to sing: "Just as I am, without one plea, but that Thy blood was shed for me, and that thou bidd'st me come to thee, I come, I come." Then the blonde was moving. There were tears in her eyes, and she was singing the song for my ears only. She approached like an emissary from her Saviour, and I glanced toward Miss Korea for guidance.

The blonde's voice invited me closer, inches away. Dressed in a choir-black skirt and what appeared to be a bridal blouse, she beckoned. Her lips were made for kissing, I thought. But her blue eyes only told me that I could be forgiven and saved; I just needed to take her hand. I so wanted to be close to both Miss America *and* salvation.

The preacher's daughter spoke quietly, "Do you need Jesus?"

I said yes and I meant it.

"And what do you want Jesus to do for you?"

I checked in with Korea. I was torn. Was it going to be Miss America or Miss Korea? I went with Korea. It was the mysterious dark hair. I whispered to the bride from Illinois, "I want Jesus to narrow the gap."

The following day in Moose Jaw, I spotted the girl from Korea leaning against the wall of the T. Eaton building licking an ice cream cone. She saw me and shrank further back against the wall. My pounding heart led me close to her, closer than ever before. With one hand, she brushed back her hair so I could get a good clean look into her eyes. Slowly and deliberately, and making no mistake, she touched the cone to her bare shoulder and said, "Oh look, I've got ice

cream on me. Would you be interested in licking it off?" I risked what felt like my life, knowing I would be expelled from school and my soul would be dammed forever if I was seen. I gently brought my mouth to her soft shoulder and removed the ice cream with my tongue. With an aftertaste of vanilla cream and mint on my lips, I stepped back admiring the job I'd done. I felt pleasure followed by shame. Did the shame bring the pleasure? Either way, I thought, Jesus had granted me my deepest wish. I did not know then that in my coming life, I would chase dark-haired women for love, blondes for sinning.

* * *

Charlotte had booked the tickets. She'd been worried about me. Daddy was having challenges with aging. The heat of summer was making me even grumpier than I was in the winter. She thought a holiday back to my father's roots might be good for us all. The plan was to fly to Winnipeg where Kelly, Charlotte's new husband, spent his boyhood summers, and where years before I'd had the brief fling with the green-eyed university student. We'd rent an SUV there and then make our way to my brother's farm in the corner of southeastern Saskatchewan. Maybe I would even ride a horse, if I could still mount a saddle. I found my plastic-covered map of Saskatchewan amid the mouldy basement cardboard, where the past lived.

In Winnipeg, Kelly recommended going to an ice cream shop he remembered from his childhood, a place that

offered ice cream and frozen bananas. On the way, we passed a 7-Eleven that Kelly had often frequented for his summer Slurpees. "Winnipeg consumes more Slurpees per capita than anywhere on Earth," he informed us.

At the ice cream shop, we found it had changed hands; there were new owners. Kelly was somewhat deflated. There were no frozen bananas, but the place, Chaeban, was clean and well lit, an air-conditioned symphony in whites, and there was still hope for there was plenty of ice cream— with a mystery of flavours and names, requiring study and explanation.

Kelly wanted to know the story behind everything, so he dug up the history of the Chaeban. A dairy scientist married a Syrian woman whose family was scattered across the Middle East due to the humanitarian crisis in Syria. The couple were new to Winnipeg, and with the local community's help, they sponsored members of the woman's family to come to the city. The couple demonstrated their gratitude by opening an ice cream shop featuring the tastes of Syria.

I admired this investigative character in my daughter's partner, and I shared a belief in the enriching powers of context. I bonded with my new son-in-law by learning the history of the ice cream shop. It was the moment when the newlyweds and the father/father-in-law became family.

Charlotte chose to get her ice cream in a cup; Kelly wanted one scoop on a cone. I chose an ice cream called Plain Jane—made of vanilla beans, cream, ice, honey, and

cottage cheese—with a mix of dread and excitement. I had hoped for two scoops on my cone but was afraid to ask. Thankfully, the woman doing the scooping saw me for who I was and gave me an extra.

I tasted ice cream for the first time the day my older red-headed brother Terry left to never return. He was sixteen. It was time to go. I couldn't have known it yet, but I would share the same fate as my older brother. When I was sixteen, my father told me that I, too, had to go because my parents couldn't afford to keep me around any longer.

The day my brother left, it was springtime and the ditches were running with meltwater. The adults had gone down to the river to collect ice for a mixing pail, and the neighbour's hired hand had gone for a last skate.

As the morning cream and ice were being ground into that soft pleasure called ice cream, the hired hand went through the cracking cover of the river. He was pulled from the freezing water, brought to the house, and helped into the kitchen. He was called Lefty, because he was missing an arm from a farming accident. Embarrassed by the fuss, he refused any help removing his skates. Still dripping river water, one-handed and one wet cord at a time, sighing rather than crying, he yanked out the laces. Placed in front of the wood stove, he shook gently, like a drummer keeping a steady rhythm. A pool of water gathered and steamed on the open oven door. Lefty had soaking-wet red hair, which made me think of my just-departed brother. Unlike my brother, however, Lefty stayed on the farm.

* * *

As we drove through southeastern Saskatchewan, Charlotte said to me, "You know, it's not near as depressing as I thought it would be." We met my brother Terry in a town called Carnduff, for I could no longer remember the route to his farm. Terry first took us to the farm of our childhood, where I had spent the first seven years of my life. We gathered around the empty pit where the house once stood; nearby were the traces of all my childhood landmarks. The abandoned well, the broken remains of the barn, the fence from which I would mount my pinto horse to go riding bareback. Terry did not have much to say about any of it. He suggested taking us to the highest nearby hill, which overlooked the valley of the Souris River, the family's former homestead, where Lefty had fallen through the ice on the day Terry left home. There was also a small cemetery there where members of our family were buried.

I was just past sixty-eight, and I surveyed the vast beauty of the prairies in the delight of summer. This was where my father had married my mother in 1929, the year the stock market crashed, the cow died, they had to salt down the pig in order to survive, and a daughter, my oldest sister, Billie, was born. Eighty-eight years after my parents' marriage, Charlotte had married Kelly, who was the theatre critic at the *Globe and Mail*. Thirty-four years earlier, I'd married Charlotte's mother, the theatre critic at the same

newspaper. This was either coincidence or contained some meaning that escaped me.

I removed my hat and stood quietly by the graves of my relatives. The one that interested me the most was that of a favourite cousin, whose headstone was carved with the most resounding epitaph: "Waiting for the shout." I reflected on the faith of my ancestors.

* * *

We made our sombre way to Terry's farm, where Kelly, like a boy in wonder, drove a red tractor the size of a small house and then a blue truck big enough to fill a Toronto parking lot. Terry saddled up three ponies, and this old actor, unable to step into the saddle, was given a humiliating boost. Charlotte got the tamest one, Terry got the wilder horse, and I drew the dud. We pranced across the farmyard and into an open field, and then something spooked the horses and Charlotte cried for help. Terry's horse was bucking and jumping, so he was unable to help as Charlotte was carried off at full gallop.

I was horrified, but Charlotte somehow stayed on the horse and returned triumphantly, and then the joy was translated into a beer on the porch where the adventure was given its due.

This old actor felt the farm boy and the old man merging then, as if a new chapter in life was writing itself in the air. Terry, who had earned his cowboy face, looked over at me, winked, and asked, "What are you up to these days?"

"I'm writing a book," I said, feeling embarrassed to say such a thing.

"Goodness, what's it about?"

"It's the story of a man in crisis," I answered. "He's living the link between grief and desire. The book makes the point that a man like this could be a public menace. Would you have anything to say about that?"

Terry didn't take long to answer. "Well, I called a guy to sell him some beef, and at the time I phoned, he was topping up the wife. I nearly lost that deal because of my neighbour's sex drive. Is that what you're saying?"

"You bet."

"Don't put that in your book."

"I promise."

Everyone had another drink.

"Thank you for our temporal blessings," I said, raising my beer and remembering my father saying it before every meal. He gave the same prayer over and over again. It never changed, and he never rushed it. My father's voice was calm and attractive, masculine with a flat Irish lilt. He leaned toward humour and liked to make people laugh, but he rarely did. He was overcome by the world, never felt like a winner. He loved but could not show it except through sentimentality. He was depressed, and who could blame him.

My dad had lost the farm, and there was no shame like that. Not that I knew anyway. He had a way of sitting backwards on a kitchen chair, his arms cradling his bowed head, his back to the oil heater. As a boy, I'd never seen anybody

sit like that except my father, and now that I was as old as my father was then, I still hadn't seen anyone sit that way. It's the way you sit when you lose the farm, lose it to a bank, I thought. A lost farm haunts a family. You don't walk away from that—it follows you everywhere.

My dad would sometimes sit for hours, never speaking. As a boy, I never asked why; I knew what the old man was doing. He was trying to warm his cold back, which had been broken when he fell off the barn. A barn he was trying to fix so it didn't fall on top of him. When you're a boy and you see your dad lying in bed for months sweating inside the plaster of a body cast with a broken back and a busted shoulder and one arm cast straight up in the air, you never forget it. My dad had a stick, and my mother would sometimes dig around in the body cast to scratch some ferocious itch that no hand could reach. It wasn't too long after the accident that my dad had to give up, and sometimes I would wonder which hurt more: the broken back, or the lost farm? When I became a man and told people the farm broke my father's back, I meant it literally. And when someone would say, "Oh, he had to sell the farm," I knew it wasn't really selling—it was losing, and losing is not selling.

A father passes on many things to his sons, and I realized losing the farm was a part of my inheritance. That night on the farm, thinking about my father, I thought you have to love someone who gives you a burden like that to carry, for it makes you soft where some men are hard, and

it makes you hard where many men are soft. Carole had seen the lost farm in my heart. That was what made her take a chance with me. The agony of the lost farm paralleled her family's pain. I carried my dad's hurt; for her, it was her parents' broken marriage and a kind of divorce that children never recover from. She trusted me to never hurt her more than she'd already been.

Terry filled me, his younger brother, in on the lost years, the years after I'd left, and he also told me about the years when I was too young to understand what was really going on. "We had that one cow, and my job was to milk it," Terry said. "It was an ornery cuss, nothing but problems. I used to whack the milking stool against her to get her in the right position for milking. Well, the old man asked at suppertime one day, 'How come that cow isn't milking as much as usual?' Fair enough, the cow wasn't milking as much, but she wouldn't move or do anything she was supposed to. I was eleven years old, and I was doing all the work. I hated that cow. I just wanted her to get into place. Well, she wouldn't, and I'd have to wail away on her with that stool to get her over. Of course, that's why she stopped milking. The old man knew something was going on. That was the thing about the old man: he wasn't stupid. That's what made everything twice as hard."

I saw the most of my father when we were both somewhat older, when we lived together at the Bible school. My dad seemed to light up around the women staff members; he only seemed happy when he was flirting. Our family

never saw much of that charm. He was one of those men who was kinder to strangers than to his own family.

An older woman once told me a story about my father when he was young. She said he was handsome and had charisma, and when he entered a farmyard, all the women would rush to the window to watch him. She said my father was in his best suit when he first met my mother. She was wearing a pretty red dress and couldn't find the gate through which to pass for a school meeting, and he cantered over on horseback, lifted the barbed wire, and one-handed her through the gap. You had to be exceptionally strong to do that sort of thing. My mother married him shortly after.

Being on Terry's farm resurrected our father in our memories. Though he was buried far away, alongside our mother, in North Battleford, Saskatchewan, he lived on in the bones of his sons.

Later that night, after the beer and the excitement of the runaway horse, Charlotte and Kelly went down into the basement where all the smells of farming lived. A couple of months later, they told me a boy was coming. Conceived on the night of the runaway horse, he would turn out to have red hair like my brother Terry.

FIVE DAYS IN FEBRUARY

Strapped tight to a gurney, I was being pushed along a labyrinth of hospital corridors, my stomach grumbling. I tried to escape the reality of it all by concentrating on the patterns of the ceiling tiles. I was feeling sorry for myself—deprived of my morning breakfast, a routine of bacon and eggs, a side of buttered toast, and coffee with real cream. Was it the smokes, the booze, the drugs, the ice cream, or maybe the lack of a gym membership? I'd lived too long without a plan A, let alone a plan B, so my ball was always lying there waiting to be played from the rough. I'd never had a clear shot from the fairway to the cup. The regrets were clinging, and I told myself they'd have to go. That was unsuccessful. I thought I should have taken more advantage of my youth. I asked myself if it had all been a waste of time. If I had lived my life only pretending to be a nice guy, when, after all, we're all pretty much the same inside,

more or less. I thought it was a pretty un-Christian hour to be facing life and death.

I was on my way for open-heart surgery—a triple bypass—stripped of body hair and rinsed in the vile disinfectant smell of the before-dawn shower I had just taken with my imaginary friend, God, as eternity mocked me for my pale confidence that everything was going to be okay. I was not ready to die, but I was heading for the unknown.

I should have gone with the blonde from Chicago who offered me salvation. I should have taken that hit of acid and spent a week in Vancouver with the long-legged woman in the sports car. Were they really playing that old chestnut hymn "Just as I Am" over the hospital speakers? In my mind, I searched for my usual alibis for alleged crimes committed and found the file had been deleted. I couldn't feel my balls or my dick. Did they remove them with the hair? I wondered. Never mind, I won't be needing them anymore. I heard the refrain "O Lamb of God, I come." And Miss America was singing.

The angina attacks had begun not long before, in 2018, while I was acting in a play called *Prairie Nurse*, about two Filipina nurses in Saskatchewan. It was a farce, and the actors playing the nurses were like sisters, close but very different. They were highly skilled at moving the heart and getting the laughs. There was no warning as to when I would have my episodes, and I wasn't sure what these events were or what I should call them. I felt myself moving, visiting foreign terrain, as it were, and these moments

felt like a pause that heralded coming pain, maybe death? I had a gripping sensation in my chest and knew something significant was about to occur. Sometimes it would manifest as dizziness. Once I felt the dreaded jaw and arm feeling—or did I imagine that? Fortunately, I was backstage when the mild attacks came, and I could rush to sit down before I fell. It was most disconcerting; I'd never known physical weakness before. It was a secret I initially did not want to share with anyone, especially with myself.

When I met my surgeon on a cold Tuesday in February to discuss the options, I shared a concern. "I'm an actor and I'm getting old and good parts don't come along very often anymore, and I have maybe the best role of my life ahead. It's a grandfather on a farm, and he has early onset dementia, can only remember his punchlines. I've been preparing for this role for a lifetime as I'm one of the few who can convincingly do old farm guys. I'm not bragging, but I might be the best in the country at this. And my daughter is about to give birth in two months. I'd like to be around for that. What sort of time frame were you thinking? I'm wondering if it would be possible to revisit this in the fall."

The surgeon had a stern and commanding presence. "I was thinking this Friday, or maybe tomorrow," he said. We settled on Valentine's Day.

This old actor was lucky to have drawn the card of Dr. Fuad Moussa. It could have been anyone, but it was the Arab innovator, whose name means "heart Moses" in

English. Dr. Moussa was one of the few heart surgeons in the world who did bypasses off the pump, which meant he did his work without stopping the heart. He operated while the heart was beating on its own. Doing it this way lessened the likelihood of dementia that can sometimes follow these surgeries.

As an actor, I risked anything for a good joke. If I had a story in my back pocket, I was happy; there's nothing I found more agreeable than a dependable punchline. I trusted they would give me the best drugs available, that it was worth risking my life for a solid legal high. This and the beautiful irony of heart surgery on Valentine's Day was like taking a trip to a Vegas casino. Show me my stool; I'd play the slots until they called me home.

I was someone who liked to control the weather in his system, numb the hangovers, learn to mouth breath through jammed sinuses, elevate the despair of casual sex. Distract the conscience when necessary. Anything was allowed if it might move the weather system and cloud cover out of my life and into the next county. I liked the sunny side of the street, but this was definitely a teaching moment, a time for new strategies to deal with bad weather. I gave myself a self-improvement workshop, an attitude adjustment—it was a class that had to be rushed.

In the corridor, the gurney stopped moving. I was stalled by a window, just short of the operating theatre, and wondered what was happening. Had the guy in front of me died? Were they sneaking the body out through the

back door so I wouldn't see it? Had the government pulled my insurance policy at the last minute?

For two hours, I was left staring out the window onto a parking lot, reacquainting myself with the already overfamiliar brick and grey of Toronto. I feared what was behind the door to the surgery theatre. The door swung open and shut and I clocked the anxious faces of the white coats on their way to some emergency. I knew how to wait. I had learned the skill from attending church throughout my childhood. All the boredom training was finally paying off. The years at Bible school had purpose; I could see that now.

The master surgeon, however, was not happy about waiting. He probably hadn't gone to Bible school. Dr. Moussa held up his arms, as if to say, Look at my highly paid and skillful hands, they're ready, and the room is not. He strutted up and down the corridor in a fury. He looked like a Blue Jay shortstop who continually hits into a double play. I, the patient, began to feel alarm bells going off. I thought it might be time to call Heart Moses over for a heart-to-heart, to find out what the hell was going on. I needed a little pep talk. I was about to summon the surgeon when suddenly he changed tack. Anger transformed into meditation. The handsome surgeon slipped his hands behind his back and, like a French emperor, paced toe to heel. He'd gone from road rage to Zen monk in seconds.

The patient with the bad heart got used to the idea of being ignored, didn't feel diminished, understood that sometimes emotions are beside the point; they're only

feelings. They don't reflect what is actually going on—they're just weather systems, and he was up against something bigger than bad weather. He needed heart repair. Feelings are like bad actors in small roles. You have to be patient, and soon they'll be gone.

Lying there, I began to review my life but quickly thought, Fuck that. No sense reviewing what can't be changed. Memory lane is the last road you want to walk before you face the end times. I should think about my future grandson and my daughter who will need a father more now than ever. Think about how good a coffee would taste right now. Think about the gorgeous woman in the outfit that screams assistant, who is whispering in your surgeon's ear. What is she saying? Please share.

Then she was walking my way. She had some news from the front, touched my arm, and leaned in close. Was she going to ask me about Jesus? No, she asked me if I'd been told what was about to happen to me, once I got inside the room that I'd not been allowed to enter yet. The mysterious room that was being prepared, the room that might become my coffin.

I managed to smile in what I hoped was a beatific manner. "No, I have no idea what is going to happen."

Her voice was warm liquid poured into my freezing body. "Your surgeon will explain it all before they give you a little sedative to help take the edge off."

This was the first I'd heard about a need for taking any edge off, but I took it as terrific news and didn't really care

about the details of the procedure. I'm a broad strokes, big picture sort of man. I leave the details to experts. I was fine about being in the dark. It was a great place to dwell if people were about to break open your breast plate and fool around in a mechanism that is so delicate it's called a heart and is a metaphor for just about everything. I nodded my approval to the assistant and felt for a moment we might become best friends, if only I believed in angels. Then she was gone, and with her went the last contact with Earth before the rocket ship took off. Houston could no longer save me. I clung to the thought of the drug they were about to administer, loving the anticipation of a calming sedative.

In the final moments before surgery, still staring out the window, a thought about Toronto appeared on the horizon. My city is a wonder of newcomers and a refuge for so many, I thought. It's not a place known for its heart, but it has one, and quite a large one, whether acknowledged or not. Going forward, I decided I would put my life into the hands of my new Toronto. That morning, the story of a man facing the truth of himself would begin. As an actor, I had learned that we are all alike; we're no better and no worse than most anyone else. It was secret actor knowledge. Life is a constant game of adversity and chance; winning and losing are only concepts; you have to face the music, and often the music is not welcome. I wanted to live for Charlotte, for the new grandson. My daughter had convinced me it was important to risk the operation, and

she was usually right about the big things, and most of the small things as well.

I was heading into the operating room, and there was a huge crowd in there. Everyone had a job to do and they knew that outcomes were never certain. It would be a long day, and I felt for them. There was a stressful shift ahead before they got their lunch. I hoped they'd had a decent breakfast. Then two orderlies rolled me off the gurney and under a lamp so large and hot, it scorched my eyes. Nobody told me what was coming. "Praise be to God." Then nothing. Full blackout.

* * *

Waking up from an anesthetic is a high bridge to cross. Initially everything was a blank; I had to build the world anew. God took seven days for Creation; after the deep sleep of the drugs, I had to be a little quicker than that if I was to get on my feet again. I couldn't seem to open my eyes; they were locked tight. As I slowly came out from under the anesthetic, I experienced a vivid vision. I was on location in a temple room in heaven, and the Filipina nurses from the play were with me. They were fierce and wild, flying demonic spirits telling nasty jokes, seeming to invite me onto the playground of life. They were wearing old-school nurse uniforms with the funny hats, starched clowns from the other side. Maybe the setting wasn't heaven after all; perhaps it was the *other* locale. I followed them, though. I was a spirit, too, and I rejoiced. They made

my new heart glad, and I felt love for them. They were welcoming me back to Earth.

I sensed a woman whispering in my ear, explaining I had heart surgery and that it went very well. She said I was looking good, and though I knew it was a lie, I appreciated hearing it anyway. That was when my eyes first blinked open. I was under a spotlight of some kind and recognized the welcome face of my son-in-law. The man was beautiful. I closed my eyes. I remembered a photograph of my son-in-law and daughter dancing at their wedding—it looked like they were skating. They aced that wedding dance, I thought, and I would ace this recovery. The worst was over; I'd survived the surgery. Everything from that point on would be much easier.

Another switch was flicked on, and it was my daughter—to me, clearly the hero of the hour. She had given me the grit to make my way through the valley. She almost never lied to me, but maybe she did that day when she said my colour was good. I was unable to speak for some reason, so I invented a sign language, gave them a little show. I wanted them to know I was all right. It was hand puppetry; I showed them my story of creation.

The nurse whispered in my ear again. The tube would be with me for only awhile longer. I had just another hour before *extraction*! I then realized why I couldn't speak and why swallowing was a kind of agony. My daughter and son-in-law were not allowed to stay long; I would face the removal of the tube from my throat alone. As they left, I

gave them a big double thumbs-up like a politician about to lose an election.

Time was up; they were coming for the tube. I steeled myself, and it was out. Just like that. No pain. Gone. My feet were dancing in celebration. I named them Fred and Ginger. The truly horrible had come to an end.

* * *

I occupied the last empty bed in the intensive care unit. There was a triangular shape to the place with desks and offices occupying the centre. When a patient went for a stroll with the aid of the unit's walker, they'd do a partial lap and return to bed. The walker squealed; it was like being accompanied by a baby elephant blowing a kazoo. The order on the second day of recovery was "Thou shalt do a victory lap with the complaining wheel." It was a clown show, and I was told it had taken place forever. The unit was a place of the highest sophistication, but it evidently had no 3-in-One oil. When it was my turn for the ritual, I waved at the crowd, the other patients cheered, and I gave them the show of a lifetime. I felt like a celebrity. This was no walk of shame; it was triumphant and celebratory, demonstrating resilience and bravery. Not quite like winning a war, but escaping death just the same.

The voices behind the next curtain over, however, were disturbed. The patient owned a successful fleet of restaurants and managed an international empire with a head office in Florida, but his heart attack came in Toronto. I

couldn't see the restaurant king or the many pilgrims coming to see him, but I could hear their loud voices and imagined their faces. It was clear their power centre was in crisis, the kingdom unstable.

The man's daughter talked in rambling monologues, disguising orders within them. The employees needed to pull their socks up. One was too downcast: his negativity could no longer be tolerated. Everyone has to worship new gods, because the patriarchy was wounded, she said. Women will have to be listened to. The world was finally changing whether one liked it or not.

The master patriarch said little, and it was assumed his silence was agreement. When he did manage a few words, everyone listened fearfully. The ruling king had a hard time addressing what was being discussed, his voice was weak, and he was angry in the way of someone who is used to being agreed with. He was extremely annoyed with his failing heart. He saw his heart attack as an insult, and there was a feeling of blame in the air. His heart had put him there, he said, but who had put his heart in the situation where it had no choice but to fail? He coughed, glanced about, searched for guilty parties. The daughter formally and effusively proclaimed her love for her father; he returned this love with short hacking coughs that signalled his survival was not assured.

Even with death lurking around the corner, however, this old actor was grateful for the distraction. I was in a fight to survive the tubes and monitors, the symphony

of beeps, the endless and unnamed drugs. I had no idea what did what, but there was one bright spot every day: some breakthrough drug that I welcomed with open arms. I went down the K-hole with ketamine, a miraculous drug that sent the world spinning, then delivered an express elevator to the top floor where you were met with a surge of confidence, where a friendly host told you that all your past decisions were great. This was when Fred and Ginger really went to town. The feet danced with the new heart—the K-hole was the most fabulous disco they'd ever known.

After a day of riding the K-horse, I would only want to sleep, but it was impossible in the unit. The lights were dimmed, but they were still very much on. And in a strange way, I felt like there were too many things happening that I didn't want to miss. There were lives on the brink, and my bed sat directly across from the disposal unit. There was a parade of people in hazmat suits carrying beer jugs of blood and piss and other unidentifiable liquids in various colours I'd never seen before. 'Round the clock entertainment.

* * *

Trisha was my day nurse, and she bonded with her patient by talking about her own life. She kept my mind off my problems by exaggerating her own. I admired her skill at this, and she had a file of themes that she liked discussing. The backed-up traffic coming in from Brampton, the deadly detours in Toronto due to road work, Premier Ford braying about hallway medicine, condos, Rogers' bad service, and

"Have you ever tried to settle a dispute with Bell?" Best of all, "that crazy president is out of bounds." But realizing what she had just said, Trisha instructs that as someone recovering from heart surgery, I must not get too excited by any discussion about the grifter.

Every morning we take out the same file and chew over the themes. There was no conversation about mortality, and my heart was never mentioned. She gave the daily blood report like she was reading about the stock market. One day I was poor; the next day I was rich. Trisha was an all-day sort of person. Ninety percent of her care was keeping the mind of the patient from atrophying; she believed in the healing power of stimulation. Celebrity gossip was highly valued. It wasn't an official part of the file, but it was often an intrusive one. If we tired of talking traffic congestion, we could end up on J.Lo's porch wondering if Alex was cheating. I thought for sure he was; Trisha was on the fence. The daylight hours passed blissfully this way. I wished I had better Rogers' bad-service stories, but I excelled when raging about TD Bank. I nearly had Trisha in tears when I made the sound of the ATM at Bathurst and St. Clair as it rejected a card. "Ah, Mr. Coleman, I hate that sound," she said, laughing.

After five days in Trisha's care, she pushed me out of the unit in a wheelchair and onto the floor where I waited to be discharged. I put on a steely face, knowing Trisha was not comfortable with patient emotion. When she was leaving me for the last time, she briefly held my hand and squeezed,

looked me in the eyes, and said very quietly, "Don't be a baby." It was both a warning and a code, a way of thanking me for pretending I had not fallen in love with her. I waited respectfully for her to go. She walked away fast, as nurses always seemed to do, but before she was out of earshot, I heard her say to someone at the floor desk, "He's an actor, makes me laugh, take good care of him." It reminded me of something my wife had said to me before she died: "God must love you, for he always brings you wonderful women." Trisha had helped me through the narrow pass and into the future. For those five days in February, and they were not short, I was Trisha's only patient, and I realized it wasn't often in life that one got that kind of attention.

※ ※ ※

My daughter put me up for the next two weeks of my acute vulnerability. I was exiled to an upstairs room and happily not dependent on my daughter or her husband for my care. I did not want to burden Charlotte as she was great with pregnancy and both she and Kelly were very busy at that time with their work. Two friends from the theatre community had organized a fund to carry me while I recuperated, and they found people who liked me enough to cook meals for me and deliver them to my front porch. The food arrived in tiffins and Tupperware and were delivered to me in the upstairs bedroom where I dwelt. After hanging by a thread between heaven and earth, it was here that I learned an important lesson: sometimes you have to let people take

care of you. You have to admit when you are unable to do what needs to be done.

My best friend and favourite musician, Jack Nicholsen, arrived every day and cooked a delicious and health-giving lunch, organized the pill-taking, made a schedule. An actress I admired for her extraordinary talent and heart never visited, but she invisibly ensured there was money in my bank account and food in my belly. It encouraged me to know there were people out there who wanted me to live. Every day, I rose from a place of weakness and began my slow journey back to health, walking two minutes, then ten, thirty, and sixty. I felt friends and ancestors walking with me holding my arm. Cradled by the help of this extended family, my mind felt sharper than it had been in my previous life. The enhanced blood flow made me feel alive to the world in new ways. I was almost certain I was feeling something like hope. When the two weeks was up, I felt well enough to return to my apartment.

A few months later, I went to the rural theatre festival and performed the part of my lifetime, the old farm guy, and found the love I'd been missing from an audience. I believed it was because my performance was influenced by what I had felt from the community of family and friends who had kept me going after my surgery. I had developed a new appetite and regard for hard work. My heart expanded when I walked to the lip of the stage to take my bow. Fred and Ginger, my two dancing feet, did a small, tasteful jig. I'd been given a second chance in life.

TRUST AND OBEY

On the way to Total Health Pharmacy, I was surprised by my reflection in a shop window. I looked like a walking skeleton, I thought, which reminded me of Uncle Darcy.

Darcy was my mother's oldest brother, the one who survived the First World War. The actual oldest brother had been shot in France while going over the top, ripped apart by machine-gun fire. He was only twenty. He never saw Paris.

The dead brother might have been my mother's favourite, but I couldn't be sure, because she almost never spoke of him. Maybe that wasn't true, for my mother had loved all seven of her own children equally. None of us felt more or less favoured.

Uncle Darcy had visited our family when I was still a young boy, and he was my favourite uncle because he smoked cigarettes. He even smoked in our living room at Bible school. In my mind, smoking at Bible school was the

most daring act a man could perform in front of people without stripping off his clothes.

Uncle Darcy would acknowledge me with a nod, as if inviting me into some sort of conspiracy. With his long thin legs in his stylish suit pants, he had an air of mystery that intrigued me, so I installed myself as his cigarette page, a ritual I imbued with deep meaning. I enjoyed bearing the ashtray for Uncle Darcy; I felt as if I was delivering a blow to my enemies, the Christian hordes. I was Samson bringing the roof down upon their heads. How I now wish that I'd known my uncle better; he seemed a lonely and haunted man.

Uncle Darcy died alone in a BC work camp. He was a logging truck mechanic, and he was found dead in his small trailer next to his work site. He'd been married to a woman who threw plates at him when she was angry, and later in life I suspected worse things had happened, if only because Darcy was forced to commit his wife to an insane asylum, as they were called in those days. It was all hush-hush, and no one ever told me the full story.

I never met Darcy's wife, but I had seen a picture of her and thought she was attractive. She made an impression on me because she was the prettiest of my aunts. I thought of her more often than the others, whether because of her appearance or because she had been institutionalized.

The Walkers, my mother's family, were thin in their old age, and one of my first childhood memories was of my grandmother Walker. I had been crawling for a couple of

days, so I was no longer marooned on the length of cardboard near the wood stove. I was on the move, discovering freedom as I explored the living room, before migrating to the bottom of the stairs of the shingle-shack farmhouse.

Grandma Walker was standing at the top of the stairs, and she looked like she'd been drawn in the air just for me. She had an appeal about her and seemed to be vibrating with the joy of living, like a tuning fork humming. As she smiled and waved at me from her great height, she made a kind of delightful cry, stretched her arms in the air as if to embrace the future, teetered, and fell. It was my first experience of slow motion, and I was transfixed as she tumbled one stair at a time, head knocking, knees banging, back bending. I was the only witness. My father came running, having heard the noise, and found my grandmother lying crumpled at the bottom of the stairs. A man with muscle, my father grabbed her dress collar and lifted her up, and as he did, her bones rattled back into place, everything jangling down. After that, I never saw Grandma Walker again. I learned later she was a suffragist, and I heard a story about her that involved my mother when she was a small girl. At one of her mother's speeches, she had fallen asleep and fell off her chair. The men in the room were horrified by the perceived neglect and shouted disapprovingly, "How could a mother put their young child in such danger?" Evidently, my grandmother set the fight for women's rights back a bit in Alameda, Saskatchewan, by allowing that one slip to the floor.

Grandma Walker was my first "someone I would have liked to have known better and never did" person; Uncle Darcy came in second. Later in my life, I learned that she was my first encounter with a non-Christian. Grandma Walker never laid her hands upon the radio. As a toddler, I had given her my heart, a woman I saw only once as she fell from the top of a great pyramid.

* * *

I was about to get my second dose of AstraZeneca and decided to celebrate the occasion by making mac and cheese for me and my grandson. I told my grandson the good news—getting vaccinated then was a big deal—and hearing this, the two-year-old responded from his high chair with his first full sentence: "Baba, I'm getting my second shot next week." I stirred the mac and cheese, added some ketchup to the little guy's bowl, and gave myself an extra-large helping. The gooey concoction inspired a memory from my Bible school days: I saw a metal bowl the size of a hot tub in the kitchen with a hundred gallons of mush in it seasoned with saltpeter, which was then rumoured to reduce sexual desire in the young. Eating mac and cheese was one of my most frequent memories of that time, along with the Spring Conference, the soul-sucking week of three services a day and missionaries arriving by the truckload to proclaim the miracles the Lord was performing in far-off places stuffed with unbelievers. Every year, there was news of a revival sweeping

the planet, a monster wave breaking and delivering sinners from the fiery furnace.

The annual conference was held mere weeks before the end of each school year; the summer, dusty and hot, then lay before me. For twenty-five cents an hour, I would weed long rows of potato fields. The dirty sweaty work under the scorching sun would buy me milkshakes and hamburgers at the highway Esso. The hamburger buns were made fresh daily and were the size of small dinner plates; the burgers were served on heavy dishes with a green ring around the edge. Fifty-five cents for the hamburger deluxe; one dollar for the special, which included pie for dessert. It was four hours of backbreaking labour for a hamburger in a perfect bun, and I never felt ripped off.

While waiting for my vaccine that afternoon, I sat in the shade on a rock beside a Scotiabank under the indifferent gaze of a security guard. Like everyone waiting for their life to change, I studied the news feed on my cellphone. Pine Island Glacier was calving, melting many times faster than scientists had predicted. It was going to raise the ocean by at least 1.63 metres. It might even be more, because this particular glacier was one that prevented another trillion cubic metres of ice from melting. A luxury liner named *Climate Change* had run into Antarctica.

After the shot, I would be two weeks away from full immunity. I did not know what the future held, but I knew who held the future. This was something I heard at the Spring Conference: nothing happens except that which is

willed by the Almighty. I didn't blame God for any of the bad things—like the bodies of children being dug up in the backyards of residential schools, or the wildfires burning the sacred forest—because in Bible school I'd been taught the concept of free will. My ancestors made the decision to steal a continent. The church helped where it could.

The Spring Conference often began with the congregation on their feet declaring its allegiance to the King, singing, "Trust and obey, for there's no other way to be happy in Jesus, but to trust and obey." You'd have to be seven years old to fully trust and obey—that was about how old I was when my parents drove me to the Bible school (the girls called it "bridal school") in the bucket of our half ton. But I never thought much about believing. I did whatever they told me to do. I gave the right answers to the questions, and it didn't matter if I believed the answers or not. Not while clipping my fake bow tie onto my shirt collar, getting it right, crawling into my suit, and making it to the church on time, my shiny pants wrinkled behind the knees and the ass saggy. I wore the suit so often it looked like I might have slept in it.

I gratefully accepted the vaccine shot and made my way back to my grandson. It had been some time since I'd driven the streets of Toronto with the windows down (at the height of the pandemic you kept them up), and along the way, I noticed women in shorts and wondered if they'd been saved. With the vaccine coursing through my body, building a Berlin Wall of immunity, I felt a revival in the air.

Hope was making me feel less tired and much younger, as if the distance between seventy and seventy-one was quite far. It had been twenty-one years since Carole had died, and yet I felt that somehow we'd become closer since our grandson was born. I sensed my late wife would approve of how I was being a good grandfather; her approval was almost all I ever wanted.

As I drove, I noticed the patios in my neighbourhood were finally open again. I marvelled at the crowds of young people flooding the streets, filling all the available chairs. Once common sights I had almost forgotten. There was a feeling of a future in the air, and I sensed a joy I'd not seen in Toronto since Ben Johnson won the hundred in Seoul. Lovers were courting each other once more, and I was not bitter I couldn't join them. A happy couple jumped out of the way when a waitress rushed the sidewalk to wait tables that were parked in a bicycle lane. Life was going to be fun again. It would be the Roaring Twenties once more.

I passed a patio where I had sat with my French writer all those years ago. The atmosphere at that table had been charged with green abundance, a New Eden feeling. She had made the world a far better place. I was awake to the air then. It was like breathing in promise, and I spent the rest of my life chasing that feeling.

It was, and remains, very intoxicating.

ACKNOWLEDGEMENTS

This book has been twenty-three years in the writing. It was inspired by the loss of my wife, Carole Corbeil, and helped along by four especially important readers: Bill Hominuke, the late Linda Griffiths, and my writing mentors Marni Jackson and Beret Borsos. With gratitude, I thank those who supported me during heart surgery, Jack and Aviva and many others, and my family spread as they are across this land and America—they are cherished by me. Specifically, my life would not be the same without the love and support of my daughter Charlotte, her husband Kelly, and their two wonderful children, Dashiell and Lyndon. You four are the bright lights in my day. I also need to thank Billie and all of my other sisters who showed me nothing but love. The kindness you showed my brothers and me could never be repaid. I would also be remiss if I did not acknowledge the Toronto Arts Council, the Chalmers Arts Fellowships administered by the Ontario Arts Council, and the Canada Council for the Arts. All have supported

this writing to various degrees over the past twenty years. I also want to celebrate and thank the University of Regina Press and my dear editor, David McLennan. Lastly, a very special thanks to my brother, Terry. Bless his farm and love for Saskatchewan.

ABOUT THE AUTHOR

Layne Coleman is an actor, director, and playwright. He was a co-founder of the 25th Street Theatre in Saskatoon and was its Artistic Director from 1980 to 1983. He was Interim Artistic Director of Theatre Passe Muraille in Toronto from 1991 to 1992 and Artistic Director from 1997 to 2007. He has written several plays, acted in both television and film, and taught acting at the University of Saskatchewan. In 2007, he was awarded a Silver Ticket Award for Outstanding Contribution to the Development of Canadian Theatre. In 2022, he won a Dora Mavor Moore for the Best Performance in a Lead Role. Born and raised in Saskatchewan, he now lives in Toronto with his daughter, her husband, and their two children.

THE REGINA COLLECTION

Named as a tribute to Saskatchewan's capital city and its rich history of boundary-defying innovation, The Regina Collection builds upon our motto of "a voice for many peoples." These beautifully packaged books are written by authors who have been caught in social and political circumstances beyond their control.

The Life Sentences of Rik McWhinney
by Rik McWhinney, edited by Jason Demers (2022)

The Girl from Dream City by Linda Leith (2021)

In My Own Moccasins by Helen Knott (2020)

Out of Mind by Shalom Camenietzki (2020)

The Organist by Mark Abley (2019)

Angry Queer Somali Boy by Mohamed Abdulkarim Ali (2019)

The Listener by Irene Oore (2019)

Florence of America by Florence James,
with contributions by Jean Freeman (2019)

American Refugees by Rita Shelton Deverell (2019)

Antigone Undone by Will Aitken (2018)

On Forgiveness and Revenge by Ramin Jahanbegloo (2017)

The Education of Augie Merasty
by Joseph Auguste (Augie) Merasty (2017)

Towards a Prairie Atonement by Trevor Herriot (2016)

Otto & Daria by Eric Koch (2016)

Inside the Mental by Kay Parley (2016)

Time Will Say Nothing by Ramin Jahanbegloo (2014)